Corrective Lighting and Posing Techniques

for Portrait Photographers

Jeff Smith

AMHERST MEDIA, INC. ■ BUFFALO, NY

Published by:
Amherst Media, Inc.
P.O. Box 586
Buffalo, N.Y. 14226
Fax: 716-874-4508
www.AmherstMedia.com

Publisher: Craig Alesse
Senior Editor/Project Manager: Michelle Perkins

ISBN: 1-58428-034-4
Library of Congress Card Catalog Number: 00-132633

Printed in Korea.
10 9 8 7 6 5 4 3 2 1

Table of Contents

Photographing Real People 1

Cameras are designed to record reality—a two dimensional record of a three dimensional world. Most photographers start to feel pretty good about themselves when they can, by the proper use of lighting, achieve a portrait that has the appearance of a third dimension. But then what?

Reality, with the appearance of a third dimension, is what the department store and mall photographers give to their clients. They produce images which are a road map of the human face, showing every inch, every pore and every line. Who wants to see all that? Even for many professional photographers, the only way they attempt to make reality easier on their clients' egos is to use diffusion for a softer portrait.

Maybe I am the only one who has noticed this, but every time I go to a lecture or seminar, the featured photographer brings out a model to demonstrate his or her theories on lighting and posing. What does this model look like? She a goddess, right? She is perfect in every detail—tall, the perfect shape, beautiful hair and the perfect clothing to complete this perfect illusion of beauty.

After the lecture, you go home, all excited about the techniques you have learned, and really wanting to try all these new ideas in your own studio. While you have all the knowledge from the seminar, you don't have that perfect model. So, you start experimenting with the techniques on your clients—and probably not with the same "perfect" results as the photographer at the lecture. After all, it is one thing to make "Ms. Perfect" look "perfect" in a demonstration, but quite another to make Mr. and Mrs. John Q.

"... these are exactly the real people that we photograph every day..."

5

Public look as good. Yet, these are exactly the real people that we photograph every day—people who are overweight, balding and much less photogenic than "Ms. Perfect."

I hate to be closed minded. Maybe, out there somewhere, there actually is a photographer who makes a good living in a portrait studio that only photographs beautiful people. If there is, I would like to shake his or her hand—and then buy the studio.

This book is for all the rest of us who have a variety of clients, with a variety of problems, but who would also like to appear beautiful in their portraits. I work with high school seniors all day long, every day of the week, and maybe five percent of them are attractive enough for their egos to handle looking at a portrait that shows them as they really are—a portrait that only depicts reality. Keep in mind, I'm talking about clients at an age where they have everything going for them. They probably will never again be as thin, with as much hair and as wrinkle-free as they are at this point in their lives. As we age, the "reality" gets harder and harder to handle, but clients still want portraits that they consider flattering and attractive.

Achieving that goal is the subject of this book.

"... clients still want portraits that they consider flattering..."

Identifying Problem 2

■ Problems: Imagined or Real

Almost every person has something in their appearance that they would change if they could. There are two general types of problems that you will come across when working with your clients. These are the imagined problems and the real problems.

The "imagined" problems are normally found in very attractive, very photogenic clients. Usually these problems are very slight. Most of the time the person who has these problems is the only one who can actually see them without a lot of careful searching. These problems are the hardest to correct because most photographers never take the time to speak with their clients about such issues before their session. Since no problems are readily apparent, the photographer doesn't give it a second thought. A typical imagined problem is something like, "One of my eyes is smaller than the other," "One of my ears is lower than the other," or "My smile seems crooked." As you look for this "freakish abnormality," you have to study the problem for several minutes to find what on earth the client is talking about.

Women are more prone to imagined problems, for they have a higher standard that they feel they must live up to. You know the double standard—a chubby guy is "stocky" while a chubby woman is "fat." An older man has "character" while an older woman is just "old." Many women feel that they must look like the girl on the cover of a fashion magazine, while most men feel they don't have to look any better than the guy next door. This is a primary reason we

"Almost every person has something in his appearance that he would change..."

have used women for the majority of the illustrations in this book. The second reason is the fact that women generally wear clothing that is more revealing than men's clothing. Guys' clothing is usually loose and helps to conceal some problems. Women wear evening gowns, more tailored clothing, tighter jeans, skirts, etc.

The "real" problems are the issues that each and almost every one of us has. We are never as thin as we would like, we think our noses are too large, our ears stick out too much and our eyes are too big or too small. These problems are easier for most photographers to correct, because they might actually realize that a problem exists and needs to be disguised in the final portrait.

We sympathize with real problems more than imagined problems, but all problems need to be softened in the final portraits if the session is to be profitable.

■ Common Problems

Neck Area. As you will notice, in many of my portraits the neck area is hidden from view in most poses, for both men and women. The neck area, from directly under the chin to the "Adam's Apple," is the first area to show signs of weight gain, as well as age in your older clients. In a later section, we will discuss the many ways to hide this unsightly area in the final portraits for every type of client.

Men's Concerns. Guys want to be appealing to girls. They want to look "buffed," not scrawny or chubby. Most guys, if they were honest (which they never are) either worry about their nose being larger than they would like, or their ears sticking out a little too far, or both. As we have already discussed, if the guys are at all heavy, they will also be concerned with the neck area or double chin.

Women's Concerns. Ladies hate just about everything from the hairline down (just kidding, but close). Women are not prone to large noses, but if a young lady has one, she won't

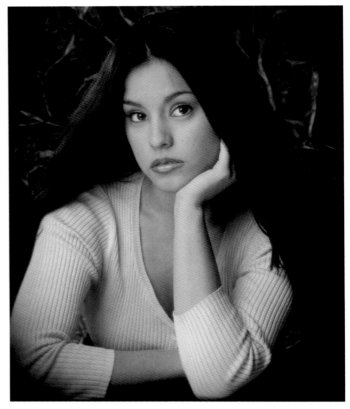

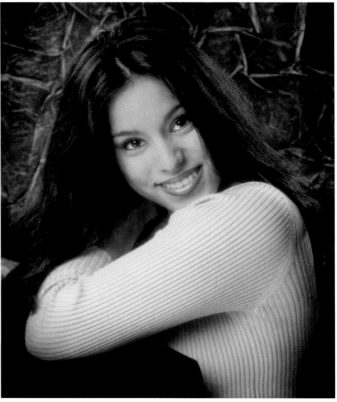

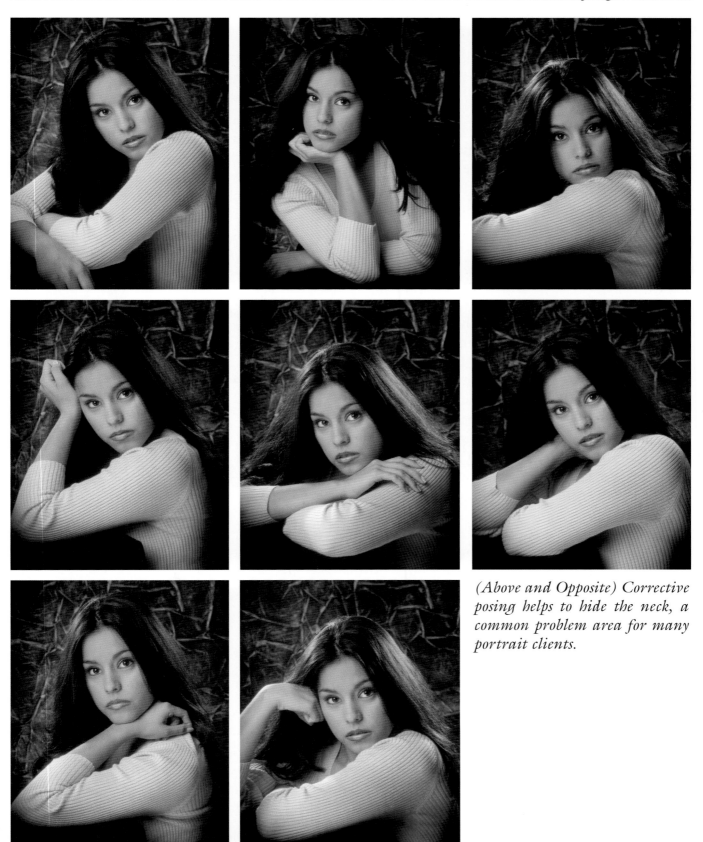

(Above and Opposite) Corrective posing helps to hide the neck, a common problem area for many portrait clients.

need to tell you to make it look smaller, because you will most definitely notice it. Ears can usually be successfully hidden by long hair (for those who have it). Women also want to have the appearance of high cheek bones, but without looking like they have chubby cheeks or no eyes when they smile.

A woman with any kind of weight problem will worry about the thickness of her face, the neck area or double chin, as well as large shoulders, the size of her upper arms and the size of everything else down to the bottom of her feet.

For the average-sized woman, the facial and neck areas usually are not a problem. Even thin women worry about the size of their upper arms or dark hair showing on the forearms.

Before I start talking about the more sensitive areas of the female anatomy, you must remember that most every person wants to be attractive to the opposite sex. Most ladies with a normal bustline want their bustline to appear at least as large as it is. As the current feelings of women toward breast-enlargement surgery are generally very favorable, it is safe to say that if a woman's bustline appears slightly larger than it is in reality, it will probably be appreciated. Many times, a pose will make the bustline appear uneven, which is the worst thing you can do.

Women always want their waistlines to appear as thin as possible. If the subject has a tummy bulge, she doesn't want to see it.

In general, the only part of the leg to show in portraits is from slightly above the knee to the ankle. Of course the legs should look like they have good muscle tone and not show any signs of cellulite. Even a thin woman will usually worry about the appearance of her hips and thighs. Unless you are a woman, or are married to one, you may not realize how much women worry about this area of their bodies. It is also generally the first area that weight goes on the body.

Some women love their feet, others hate them. About ten years ago, we started photographing seniors barefooted when the clothing and sets were appropriate. The idea caught on, and became very popular with young ladies who usually spend a lot of time putting polish on their nails. We quickly learned how much some woman hate their feet when we asked them to remove their shoes and saw the looks of horror that filled some women's faces.

Diffusion

I hate to say "always," but 98% of the time we diffuse each portrait that is taken. Since we are working with subjects who are at an age when skin clarity can be a problem, we recognize that their complexion can't handle the clarity of today's lenses. We use the Glamour Softs by Sailwind (#1). It softens the portrait without losing the critical sharpness in the eyes. I like to use a drop-in filter for easy focusing, especially as I get older.

(Opposite) Women always want their waistlines to appear as thin as possible. Switching from a straight-on pose (A) to a pose with the body turned (B) helps to slim the waist.

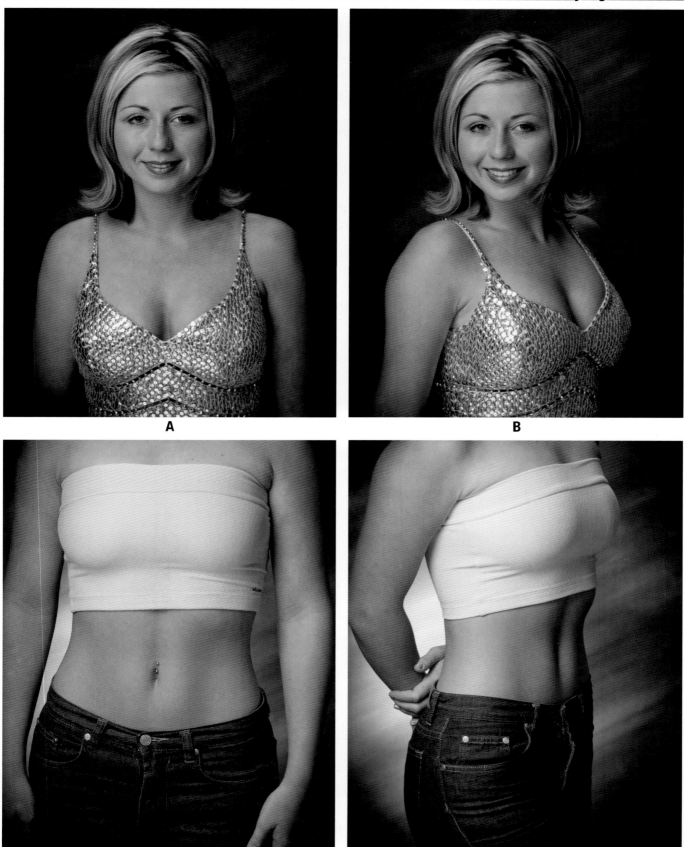

A

B

A

B

Corrective Lighting and Posing Techniques

■ Evaluating a Client's Problems Quickly

I love when photographers talk about not having enough time to do things a better way. Every time the subject of doing a consultation arises, photographers say, "Not enough time." Unlimited clothing changes? Not enough time. I am sure many photographers are thinking to themselves, "Going through all this to make my clients happier with their portraits? Not enough time."

Fortunately, the process of summing up the problems a client has is one that can be done in a matter of seconds. When you sit someone down with the main light turned on, you can immediately start to see what that person's strengths and weaknesses are. You can see how wide the face is, how well the subject's eyes reflect light, flaws like one eye being larger than the other, large noses, or ears that need to be hidden.

As you sum up the problems that need to be addressed, you can start to make decisions about on what side of the subject the main light should be placed, what poses you can use to hide this individual's flaws, which of the client's outfits would give you the most to work with (in terms of disguising the problems the client has), if the person should do full lengths or not, or if they have long enough hair to hide the shoulders and arms so the client may wear sleeveless tops.

The longer you practice using corrective lighting and posing, the faster and better you will get at identifying problems and developing workable solutions. It is just like when you started into photography. You would photograph someone, and when the proofs came back you would find that the subject's feet

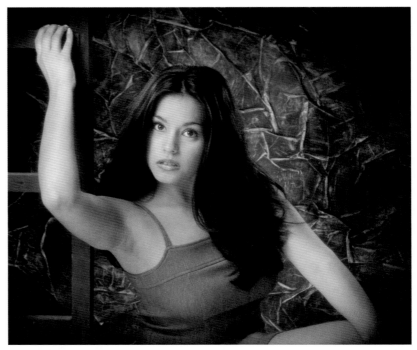

(Above) Helping your clients achieve facial expressions that are flattering and natural-looking is a part of making them look their best.

weren't right, that their hands looked funny, or that their clothing wasn't laying properly. In time, you learned to "scan" the subject quickly from head to toe and identify anything in the pose or clothing that wasn't right. The same is true for finding and correcting client's problems; once it becomes familiar, it just takes a few seconds.

Facial expression can set the mood for the portrait. From serious and moody, to happy full smiles, work with your clients to create the best look for each portrait.

2 | Working with Clients

We, as photographers, worry constantly about improving our lighting, our posing and even our marketing plans, but often we completely overlook the most important part of our businesses—our clients. If you think, as many photographers do, that you know more about what your client should have than your client does, your client will prove you wrong every time. You may be the creator of "your art," but the client is the one who must live with your creation and, in the end, the one who determines whether it is "art" or not.

We are very conscious to deliver to our clients the products they want. We talk with them as much as possible. We ask questions, give the clients questionnaires and try to make the exchange of ideas (and problem features, real or imagined) as easy as humanly possible.

Still, although most clients will quickly select the ideas, poses and backgrounds they want done in the session, most clients will not come right out and tell you what they consider to be problems with their appearance. They won't write it down on a questionnaire. The majority of the time, the mothers of the seniors are the ones who alert us to issues with their sons' or daughters' appearances—and even this doesn't happen as often as we would like.

To practice corrective lighting and posing in your studio, you have to learn about human nature. Most of us worry about the same things. We are not as different as most people think. After working with seniors for eighteen years, I pretty much know the areas of the face and body that

"...often we completely overlook the most important part of our businesses—the clients..."

14

the average seventeen year old man or woman worries about the most.

■ Communication Skills

Call it communication, call it talking with your clients, or call it a consultation, but before you create a portrait for a client (a portrait that you actually want the client to purchase), you had better figure out what that client expects his or her portrait to look like. As you talk with your client, you must be sensitive to his or her feelings. People are embarrassed by the flaws they have. As a professional, you must make it easy for them to tell you what the problems are.

This will be easier if you educate your clients from the beginning. Let them know that everybody has things in their appearance that they would change if they could. Explain that, if you know what the client's concerns are, you can easily correct many problems in their portraits.

With our seniors, we have prepared an 11x17-inch brochure which explains the basics of what they need to know for their session. In this brochure, we carefully explain that, although we can correct problems in someone's appearance (like weight, double chins or large noses), we cannot correct the problems that arise from not planning their session properly.

It is important to define what problems you can fix. Some clients will assume that your studio will take care of all their problems. When they come in with wrinkled clothing, unwashed hair and thick glasses (with the glass still in the frame) they will say, "Well, you said you would fix all the problems in my appearance!" We go over what can be corrected in the lighting and posing, what negative retouching can correct, what artwork on each print is and what it costs them (the client), in the event that they don't want to take the time to prepare for their session properly.

In business, almost every problem that arises comes from a lack of communication. In a portrait studio, most problems stem from clients not knowing what their responsibilities for the outcome of their session are, or the photographer not knowing what the expectations of his or her client were. Because of this, we make our seniors aware from the beginning that to be happy with their session, they must:

1. Explain to us if there is anything in their appearance that they would change if they could.

"You had better figure out what that client expects his or her portrait to look like."

2. Follow the guidelines given to them on how to prepare for their session. This information is provided to them in an 11x17-inch brochure and in more detail on a consultation video.

3. Come in to the studio thirty minutes prior to their session and select the backgrounds and poses they would like to do in their session.

Over the years, countless photographers have e-mailed or called the studio about purchasing a copy of our consultation video. Most photographers realize the importance of giving their clients all the needed information, but they don't know how to get started.

To put together a personal consultation, a consultation on video or an information brochure, you start by having a meeting with your studio staff (for some of you this will be easy, because you will be the only person in the room). You get out a piece of paper and make two columns. In the first column, list every complaint you and your staff have about your clients. List every single one, no matter how trivial. In the second column, list every complaint that you and your staff have received from your clients about your studio.

Once you have listed every problem, you will see that the root of almost every one of them (in both columns) was that your clients didn't know something about you, or you didn't know something about them. That's the information you need to include in your consultation (be it face-to-face or on video) or in an informational brochure.

If you are doing a personal consultation, think of a visual way to illustrate each point for a slide presentation to add impact and to keep your clients' attention. If you are putting together a video consultation, take those visual ideas to illustrate each point or problem to a video production company. This takes time and money to put together, but you will find it does away with many of the problems you currently have in your studio with your clients.

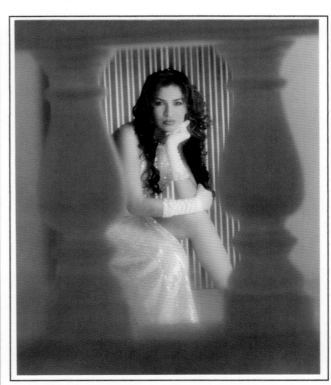

How to Look Your Best in Your **Senior Portrait Session**

Jeff Smith's Photique

This Ten minute Video is a Vital Part in the Successful Outcome of Your Session.

We use a short consultation video to get clients ready to look their best at their senior portrait sessions.

In our studio, seniors have over five hundred different backgrounds, projection backgrounds and sets to select from, as well as five scenic outdoor locations around the valley in which we live. We have twenty sample books with thirty sample portraits in each one. Every sample portrait in these books shows a different background, a different pose, set or scene from one of our outdoor locations. With that much variety, Step 3 (having clients arrive thirty minutes early) is a must. Some of our sample portraits appear below and on the next six pages.

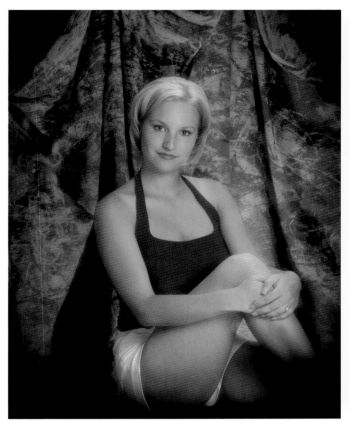 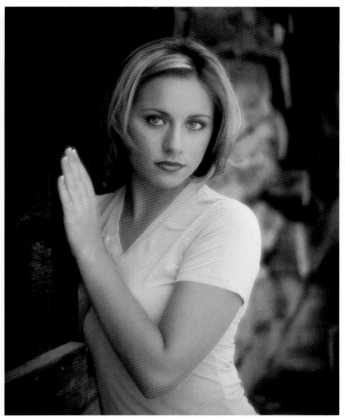

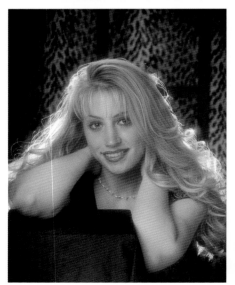 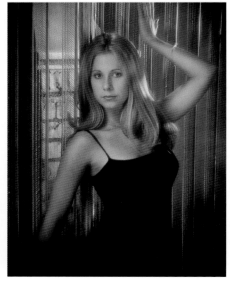

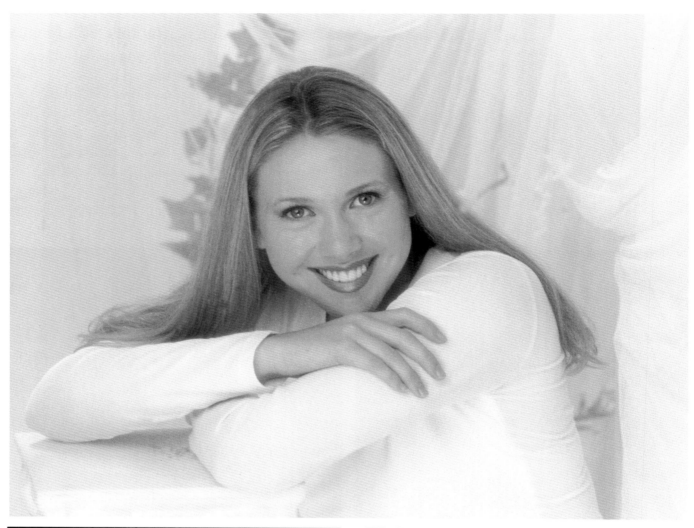

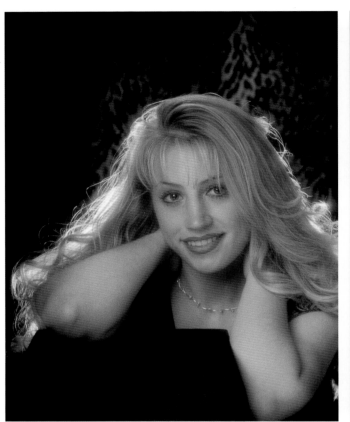
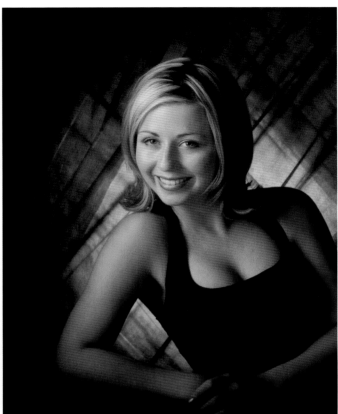

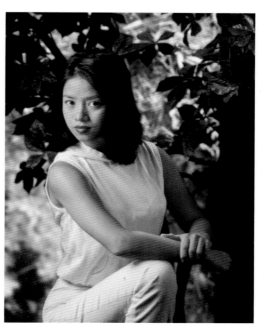

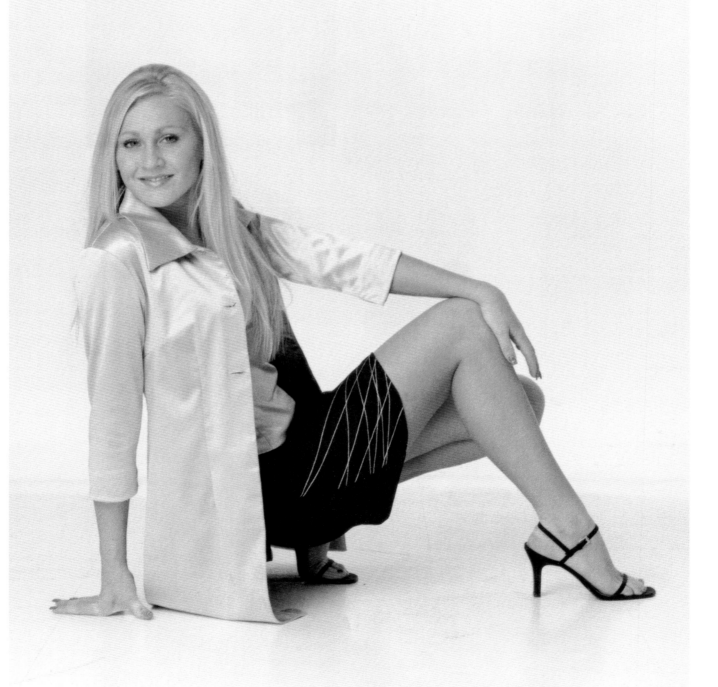

I don't want clients to have to settle for a session that is taken to please me or to suit my personal tastes. I want each pose, each background and each expression to please the client and be selected to suit their own tastes. The only way this can happen is to let the client be responsible for telling me what they want.

There are so many photographers who are into the "me" way of thinking. When presented with a new idea or something that is outside of what they are used to, they quickly dismiss it with a "Well, I don't like that!" or "That just isn't for my studio," or "We are a traditional studio and we don't offer things like that!" Remember, you may own the studio, but you work for your clients! The question isn't whether or not you personally like a new idea, but whether your clients would like this new idea. I introduce into the books almost every new idea I see. Then I let my clients decide whether it is a good idea or not.

■ Making Your Clients Feel Comfortable

There are many ways to get a client to tell you if there is a problem without making them feeling embarrassed or awkward. When we are talking with a client, before we start the session, we start by asking questions to which the client only has to answer "yes" or "no." As we ask these questions, we soften the approach by stating that many women worry about this particular problem.

A typical situation occurs when senior girls bring in sleeveless tops. The minute I see them, I explain, "Sleeveless tops are fine." This doesn't make the senior feel like an idiot for not following the guidelines we

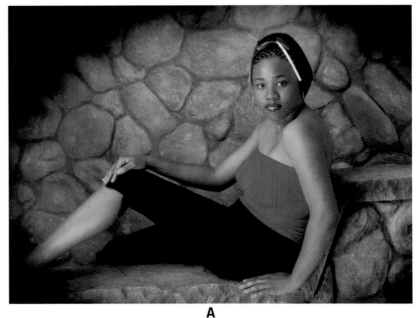

A

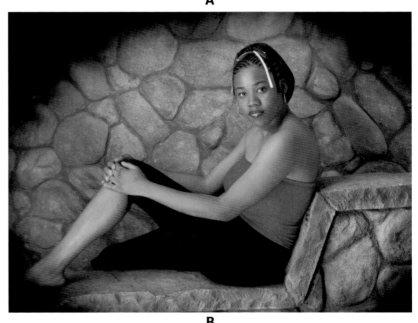

B

(Above and Opposite) Not every pose is for every person. Select poses based on your clients' individual needs and refine them to create a flattering appearance. These examples show how a simple change like moving an arm from one position (A) to another (B) can improve the pose.

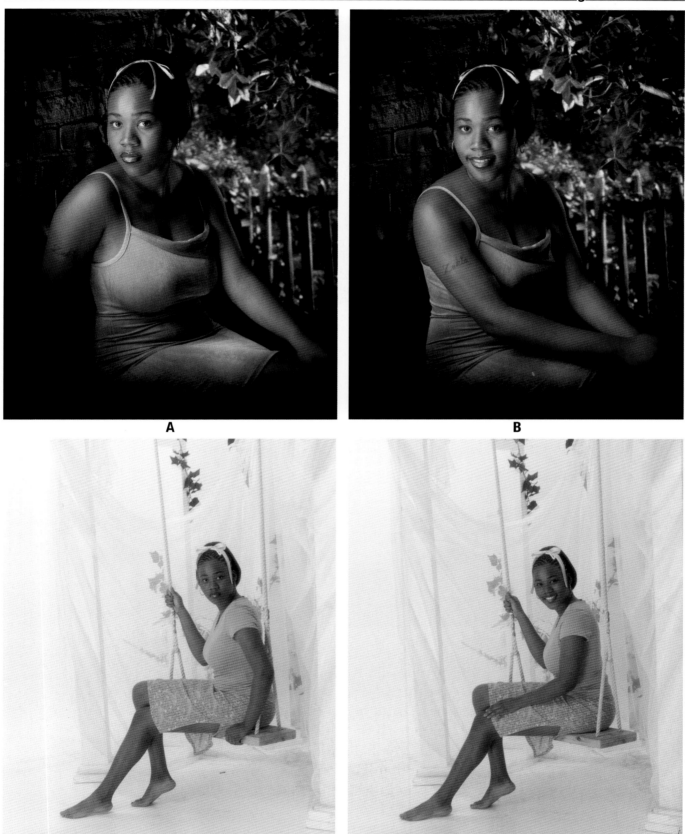

A

B

A

B

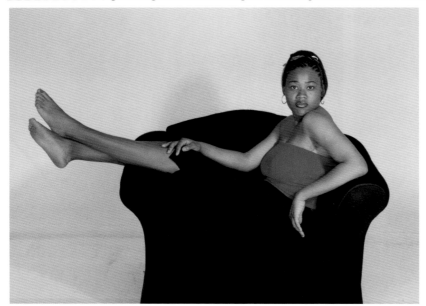

A

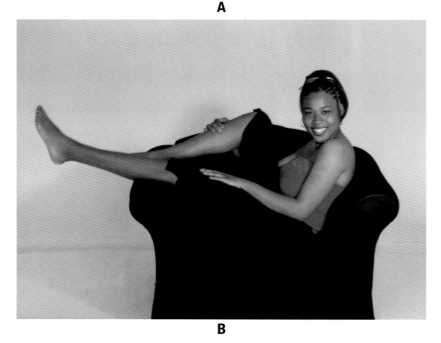

B

(Left) A simple change like moving an arm from one position (A) to another (B) can improve the pose.

have given to her in all the information she has received. Then I continue, "The only problem is that a lot of ladies worry about their upper arms looking large in the photograph, or hair showing on the forearms. Does that bother you?" Either they will smile and say "yes" or they will say "no." By phrasing your question carefully you can make it easy for them to voice their concerns without being embarrassed.

The best way to handle a possibly embarrassing situations is to give the client two options, so no answer is need-

"...make it easy for them to voice their concerns..."

ed. We do this with the "barefoot" issue. Rather than ask if a girl hates her feet, we explain: "With a casual photograph like we are doing it looks cute to go barefooted. If you don't mind, you can come out of the dressing room barefoot, but if you'd rather not go barefoot you can keep your shoes on." When the girl comes out of the dressing room, not a word needs to be said.

The hardest spot to be in occurs when a client wants to do a pose that you know she or he should avoid. For instance, a really heavy girl selects a pose from the sample books of a thin girl in a very striking pose. What do you do? There is only so much that corrective lighting and posing can do. No matter how you pose or light a girl who is 80-100 pounds over weight, in a full-length pose she will not appear thin enough to be acceptable to her. In a case like this, you must advise the client to do poses that are head and shoulders.

Situations like this happen more often than most people think. To sympathize with these clients, you must understand why this happens. When I first started into photography, I would think to myself, "Hey, that girl has arms like a tree trunk and she brings in nothing but sleeveless tops—what an idiot!" Back then, I resented these clients who didn't listen to the suggestions I gave them on clothing. I felt that they made my job harder.

"A client wants to do a pose that you know she or he should avoid. What do you do?"

What I didn't understand is the way human eyes and brains work to save our egos from having to handle reality when we look in the mirror. You might gain ten or twenty pounds and lose some hair—yet, it is not until you see yourself in a picture that you really notice these changes. You think to yourself, "I look in the mirror every day. Where has this fat, old, hairless guy been hiding?"

The same thing happens when we try on clothing. The clothing looks good because when we look at ourselves in the mirror, we suck in our stomachs. When ladies try on a dress or pants, they push up their heels, making their legs and seats look better. Unfortunately, then they decide to wear a pair of flat shoes with the outfit because it is more comfortable.

Many ladies want to do a majority of their sessions full length for no other reason than to show the entire outfit they purchased for the portrait. They bought and paid for that skirt and shoes and they are determined to show them off. Unfortunately, if they have a real weight

problem, you need to explain to them that they shouldn't do full-length poses. Be sure to express it in a way that doesn't makes the person feel embarrassed or unattractive.

When I see a heavier girl with a lot of boxes of shoes, I know I am going to have a problem and I need to say something the minute I show her into the dressing room. I first explain, "Many ladies go on a shopping spree to buy a matching pair of shoes for every outfit. Since they bought them, they want them to show in their portraits. The problem is that when you order your wallets for family and friends, the full-length poses make it very hard to really see your face that well." (This gets the girl to accept that not all the poses should be done full-length.)

Then I continue, "Most women worry about looking as thin as possible. The areas that women worry about the most are their hips and thighs. This is why most of the portraits are usually done at least from the waist up, not to show this area." Next I ask, "Now, are there any outfits that you want to take full-length, or do you want to do everything from the waist up?"

If the girl has a weight problem, she will usually think for a second and say she wants everything from the waist up. This avoids telling her she can't take full-lengths, or being brutally honest and telling her she shouldn't take them.

Should the girl be really attached to her shoes and not follow what I am trying to tell her, I then go to the parent or friend she is with and explain that if we do the portraits full-length, I worry that she won't like them, because women worry so much about looking thin. Once I explain this to the mother, she can tell her daughter not to do full-lengths, or a friend can help enlighten her without causing embarrassment.

In dealing with your clients, it is not so much what you have to say that is important. Rather, it is the way you say it. For every problem and possibly embarrassing situation there is a way to handle it without making yourself look unprofessional, or seeing your client turn red. When we are working with our clients, we never say that someone is fat, overweight or unattractive.

If you can't find it in yourself to handle your clients with the same professionalism that doctors and other professional do, I am sure that another photographer in your area can.

"... express it in a way that doesn't makes the person feel embarrassed..."

■ Really Listening

Everyone has a feature or aspect of their appearance that they are self-conscious about. Some of these problems are so slight you might not even see them, but that is irrelevant. The client will see them, and the client is the one paying the bill for the portraits you create.

Often, photographers forget "who's paying the bill" for their creative endeavors. I was once at an outdoor location that is used by several other local photographers. As I was waiting for my client to change her clothing, I had nothing better to do than listen to another photographer working with his own client. The subject was a young woman, a few years out of high school. The photographer instructed his client to hop up on a rock that was near the pond. As the woman sat down, her pant leg inched up, revealing her white socks gleaming out of her dark blue denim pant leg. She asked, "Are my white socks going to show?" The photographer, who was obviously about as compassionate as he was educated in customer service, quickly responded, "Hey, if you didn't want them to show, you shouldn't have worn them!" He then proceeded to take the portrait full-length showing the white socks.

How hard would it have been to compose the portrait as a close-up or 3/4-length, or have the woman take off her shoes and go barefoot? Instead, this photographer refused to try something outside of what he had always done. That was probably his favorite rock, and he took every portrait at "His Rock" and as a full-length—or he just didn't take it. This photographer probably also hangs out at the local camera store's coffee pot, complaining to the other photographers about how bad his clients are.

"Our job is simply to fix it."

In our profession, the old saying "Ours is not to ask why" certainly applies. Our job is simply to fix it. A client's problems may seem insignificant to you—you may even think they are funny. That's okay, but if you want to live very far above the poverty line, you had better take these problems seriously and make sure that your client doesn't see them in his or her final portraits.

■ Tact

Photographers don't usually spend a lot of time thinking about how to talk with their clients without offending them. While watching photographers work with clients on various occasions, I have heard photographers instructing their

clients to: "Sit your butt here," "Stick out your chest," "Suck it in just before I take the picture, so your belly doesn't show as much," "Look sexy at the camera," and "Show me a little leg"! Hearing instructions like this makes me so proud to be a professional photographer. I am sure the women who were instructed in this way didn't feel very comfortable with or confident about their chosen photographers.

Whether you are discussing a clients' problems or directing them into poses, there are certain words (words that you may use every day) which are unprofessional to use in reference to your clients' body parts. In place of words like "butt," chose "bottom" or "seat." Never say "crotch," just tell the client to turn his or her legs in one direction or another so that area isn't a problem. Instead of "Stick out your chest," say "Arch your back." Replace "Suck in your stomach" with an instruction to "Breath in just before I take the portrait." To direct a client for a "sexy look," simply have the subject make direct eye contact with the camera, lower her chin and breath through her lips, so there is slight separation between them. Instead of saying something that makes you sound like a pervert, rather than a professional, just explain in simple terms exactly what you want your client to do.

No matter how clinical you are when you talk about a woman's breasts, if you are of the opposite sex, you will embarrass them. The only time it is necessary to discuss that part of the anatomy is when the pose makes the woman's breasts appear uneven. When this situation comes up, I just explain to the client how to move in order to fix the problem, without telling the client exactly what problem we are fixing. Once in a while, we have a young lady show up for a session wearing a top or dress that is really low cut or "used to fit." In this situation, you need to find an alternative for your client. If there is way too much of your client showing, you may explain that this dress is a little "low cut" for the type of portraits she is taking.

"In this situation, you need to find an alternative for your client."

Corrective Lighting 4

"There are
four basic ways
to hide flaws..."

Finding the flaws is easy. Making sure they don't show in the final portrait is the challenging part. There are four basic ways to hide flaws: lighting; posing; clothing, and background/set/props. All four work together to produce a final portrait that will not damage your client's ego. In this chapter, we will examine how lighting can be used correctively.

Because of our training, most photographers might think that corrective lighting would do the most to hide flaws. Well, it doesn't! In fact, it is our "training" in how to light a portrait that is the biggest problem. When we start to learn about lighting, we learn that light is said to be our virtual "paint brush." Light is held in such high regard. We hear about it all the time—window light, north light, soft light, etc. Educators of photography like light so much that they use enormous sources of light which is, in theory, to reproduce soft light coming from a large window that faces north.

In our obsession with light, we have designed larger and larger sources of light, to ensure that the light is soft. But as we all know, the larger something is, the less control you have over it. North-facing window light was used by many of the classic painters, basically because they didn't have anything else (the light bulb and the electric company hadn't been developed yet).

While this window light obviously had no controls, the artists could begin with this light, as well as the shadow, and manipulate it with the use of their oil paints. Even some of the very accomplished portrait photographers of today use a

Equipment Selection

Photographers always e-mail me or ask me questions when they see me at a convention or seminar. Usually they ask about f-stops and camera settings. The next common question is about the brands of equipment I use. I don't usually specify which brands of lights and boxes I use, because I don't want you to feel like you must have that brand or kind of equipment to do what I am talking about. If you don't have something, make it. If you are just starting out and you have more time than money to spend on equipment, get some cardboard and a hot glue gun and make the louvers for the soft box you already have. If you use flash fill and don't own a reflector, mount some dull mylar on a piece of cardboard or get a large piece of white foam core.

I don't list the brands of light I use, because the list would be too long. When I started into photography, I bought the best quality that I could find for the cheapest price. It's a practice that I still use today. I think we have a light from almost every manufacturer. They all have good and not so good points. When using negative film, light is light. If you are unfortunate enough to use slide film regularly, purchase the best lights you can afford with UV coated tubes to avoid visible variations in color that inexpensive lights may produce.

huge light source with no controls, and then rely on their artists to manipulate the light and shadow to make it pleasing to the eye. This is very expensive to do and I think the real "artist" is the one doing the artwork. If you follow this line of thinking, just have your artist correct the flaws you identify in each of your clients—or have them digitally retouched out. Then all you'll have to shoot is a portrait that shows reality with the appearance of a third dimension. Someone else can do the rest for you.

■ Shadow, Not Light

Corrective lighting actually relies on shadow, not light. Any student photographer with two lights and a light meter can create a decent portrait. Put the main light at a 45-degree angle to the subject, put the other light behind the camera, with umbrellas on both. Meter the lights to get a reading of the main light being two stops more than the light behind the camera. Stick a diffusion filter on the lens. There you have it. I have just taught everyone with any knowledge of photography to create a realistic portrait with the appearance of a third dimension.

This is why so many photographers hate the mall and department store studios. This is the lighting set-up they use. It is easy to learn, easy to use and for most of the buying public it is acceptable for a cheap portrait. Unfortunately,

"Corrective lighting actually relies on shadow..."

this is also the lighting set-up that many professional studios use. While clients will accept this type of portrait if they are getting it cheap, they are not going to pay a professional studio's price for something they could get at the mall for much less. Professionals need to deliver more than an "acceptable" portrait. This is where shadow comes in.

It's obvious that not much would happen on a piece of film without light, but what creates dimension in a portrait? Is it light? Is it shadow and the transition from highlight to shadow? Indeed, shadow is our true paintbrush. It is the darkness that draws the viewer's eye to the light. It is shadow that gives a portrait dimension, and shadow that allows you the ability to disguise your clients' flaws—flaws they aren't paying to see (or, perhaps better, flaws they won't pay for if they do see them.).

Corrective lighting is about control of light, but even more importantly about control of shadow. In a basic lighting set-up like I described earlier in this section (I call it "Shotgun Lighting"), control is impossible. Combine a large main light and a fill light with the white walls of most studios and you have light bouncing around off of everything. The three pitfalls of the average lighting set-up are:

1. **Use of a main light modifier that is too large and uncontrollable.** Because of our love of light, we reason that bigger is better. In fact, the larger your light source/modifier, the less control you have. If you use umbrellas and want to control your light better, throw them away and buy a small soft box with louvers.

2. **Use of fill flash instead of reflector fill.** The fewer lights you can use in your camera room, the more control over the lighting you will have. When you use fill flash, you get fill everywhere and have no control of the shadow formation in specific areas.

3. **Use of light-colored camera rooms.** These add to the lack of control in the shadow areas. In corrective lighting, I want light to fall only and precisely where I put it. That can't happen with white or cream colored walls and floors. These light-colored surfaces themselves become a source of fill light, just like using a white reflector.

Conceal the Flaws
But
Light for the Subject

Of course, you can't light a subject just to correct flaws. Consider how you'd shoot a portrait of a subject in glasses. This is an excellent example of lighting to correct the flaw (glass glare). You select the light to make the glasses look good, rather than to make the subject look good. Of the many ways I have seen and tried to eliminate the glare in glasses, I have never seen one that doesn't make the lighting on the subject's face suffer to correct the flaw. As a professional, you have to know when to use correction and when to inform your client of his or her responsibilities for the outcome of the session. In this case, empty frames or the new non-glare lenses are the only way to ensure a pleasing portrait that is taken to make your client look their best.

Camera Settings and Exposure

As I talk about photography, especially lighting, photographers always ask questions about exposure and f-stops. Although it is important to get an accurate exposure on the negative, the exposure that a photographer used to create an image has less to do with the beauty of the image than any other factor. If a truly beautiful portrait was taken at 5.6, would it have been any less beautiful if the all the lights were powered up and taken at f-8? The background may have a little more texture, the diffusion effect may be slightly lessened, but the image will still be beautiful.

You should select the light output necessary to give you the camera settings you feel will create the best results. If you have a wild background that needs to be tamed (like many I paint), you need to power down the lights so you can open up the lens and throw the background farther out of focus. If you have a very delicate background that will have no texture if the lens is opened up, you can increase the power to your lights and stop down the lens so you can see the few background textures that exist. The same is done to control the diffusion effect that is desired.

For our portraits, the main light generally meters at f-16 and we set the camera for f-11. Many photographers meter the main light and set the camera on that aperture. This means that the shadow area will be one to two and half stops underexposed and not properly record with the latitude of negative film. By overexposing the highlight by one stop, both the highlight and shadow will record to printable levels on negative film.

"The low key area is where we use corrective lighting."

■ **Camera Areas**

In our studio we have four camera areas. One is where we do our yearbooks, one is our high key area where we use exclusively high key sets, one is a low key area, and one is where we use the front projection system. The low key area is where we use corrective lighting.

In the yearbook area, we use a simple lighting set-up. We use a huge light box in a room with light colored walls and

(Left) Our yearbook area is set up to create an easily repeatable portrait that will be uniform from one senior to the next. (Right) Our high key area is where we do most of our full-length portraits.

"I like my portraits to have a little more glamorous look..."

light bouncing everywhere. We do this because the yearbook area is used by the least experienced photographer in the studio, and we need a completely repeatable process to ensure that each senior's background is the same as the next.

The high key area is where we do most of our full-length portraits. For this reason, we use a 72-inch Starfish, because the light must be at a greater distance from the subject. We all the know the principles of light. The closer a light source is to a subject, the softer the light from the source is. Pulling that same light source away from the subject reduces the size of the light in relationship to the subject, producing light that is harder and more contrasty.

I like my portraits to have a little more glamorous look, so in each camera area there is a light or reflector that is placed underneath the subject. In this high key area, we use a 30x40-inch soft box. This light meters two stops less than the main light.

(Above) We use a heavy-duty drafting table covered with thin mylar as a posing table and reflector. (Left) In our low key camera area, everything is dark to ensure that light won't bounce around.

In the other two camera areas, we use a reflector under the subject, since most of the portraits in these two areas are done from the waist up. To act as a posing table and reflector, we use heavy-duty drafting tables and cover the tops of the tables with a thin mylar. We use these tables because they can support the client leaning on them to pose and, with the table top that can elevate on one side, we have control over how much light we want to reflect onto the subject.

In the low key camera areas, where we use corrective lighting (and front projection), we had to deal with all the pitfalls that reduce the control you have over your lighting. Thus, the entire area is black—walls, floor, etc. Even the props and furniture are all black, or least very dark. This ensures that no light is bounced off the walls or items in the room, so I can put light and shadow exactly where I want it and not have it diminished by the surroundings.

■ The Main Light

The main light that we use with corrective lighting is a 24x36-inch light box, with a recessed front panel and louvers. This allows us to put light precisely where it is wanted, without it spilling into areas where it isn't. The size of the box allows us to get a softer light when the box is placed close to the subject, but we can make the light more contrasty by pulling it back just a little.

Unlike with large light modifiers and very soft light, when using a smaller light source and more contrasty light, you have to watch out for shadows in unwanted places. With softer light, the subject's nose can be positioned straight at the camera, or even a little to the shadow side of the frame and receive an acceptable amount of illumination. With the increased contrast of a smaller light source, you can get some harsh shadows on the unlit side of the nose.

Another difference between a large light source and a small louvered box is the ability to feather the light. With large light sources that don't have a recessed front, you can feather the light off the subject, using just the edge of the light to soften the light, or to cut down on the light output. If you try that with a small louvered box, you will have light fall off on the highlight side of the face. The light from this type of box goes precisely where you put it and nowhere else.

The louvers on the main light control the light from side to side. They eliminate light rays from spilling out of the side

"... you have to watch out for shadows in unwanted places."

A

B

of the box (like the other modifier we use in this area, which is a 42-inch Starfish). To control light from the top and bottom of the box, you must either feather the light off, or use a gobo to block the light from hitting areas that you want to keep in shadow. With a sleeveless top on, the white skin on the arm and shoulder is the closest part of the body to the main light. If the light isn't blocked, you would have glowing skin with diffusion (see page 59 for an example).

(A and B) In addition to louvers, we also use a 42-inch Starfish as a light modifier. This light must be feathered carefully to keep the desired areas in shadow.

■ The Fill Light

To fill the shadow only where it is wanted, we use reflector fill. For any of you fans of using a flash to fill the shadow, you are about to be offended. I (like all young photographers) was taught that you use a flash to fill the shadow. You put this enormous light source at the back wall of the camera room, that literally fills your entire camera room to a certain level of light. I was then instructed, as most of you were, that to avoid a flat lighting you would use a ratio between the main light and fill of 3:1 without diffusion, and 4:1 with diffusion.

I worked with this for quite some time. It wasn't until a young African-American woman came into my studio and

talked with me about doing her portraits that I saw a problem. She asked me if I had ever photographed an African-American person before. I thought for a minute and realized that I never had.

Now, you have to remember, I started studying photography when I was fourteen. I did my first wedding when I was sixteen and opened my studio eighteen years ago when I was twenty. This incident occurred right after I opened my studio in the small town that I grew up in. I went to school in this small town from fourth grade through high school and there were probably four African-American students in our school system in all those years. Although this town didn't have many African-American people residing in it, it did have many people with different ethnic backgrounds, and all shades of skin color, which I had always photographed in the same fashion and with the same lighting ratios.

I tell this story, not to bring up the differences between all of us, but because when this lady asked me her question, I realized for the first time how limiting the use of fill flash was. My first thought was, "Wait a minute, I use a 3 or 4:1 ratio, but that is for a light color of skin. What ratio do I use for the other shades of skin—all the other shades of skin?" I then asked why she would ask me that, and she explained that she had had her portraits taken several times, at several places, and they just didn't look right. She said they had very heavy shadows.

Well, I did the session, but I did it with a reflector for fill, so I could see on her face, with her skin tone and facial structure, how much shadow or fill I wanted. She loved the portraits, and I learned a major lesson. You can know what the ratio of lighting is by metering, but when you use a flash fill you will never know what the "perfect" ratio of light is for each individual's skin tone and facial structure—until you see the proofs.

In this country we have such a variety of people. All are from different countries, with different shades of skin, different facial structures and have (need I point out?) problems and flaws to hide. The only way to evaluate the right amount of fill is to see it with your own eyes. There are some of the old masters who use flash fill and create some breathtaking images doing so. But these photographers have been using this lighting for years, and have become very gifted at determining what the correct ratio of light will be for an

"I realized for the first time how limiting the use of fill flash was."

A

B

individual client's skin tone and facial structure. I don't know about you, but I didn't want to take twenty years to master the lighting I use.

If you don't believe that skin tone makes a difference, photograph three people with the exact same light on them and the background. The only difference should be in the three subjects' skin tones. Select one person who is very fair, one with an olive complexion or a great suntan, and one person with a very dark complexion. When you get your proofs back, you will see the difference in the backgrounds of all three people. The very fair person will have a very dark background, the olive or suntanned person will have a background that is normal and the person with the dark complexion will have a very bright background. Unless photographers have to deal with the consistent backgrounds of a yearbook or other publication, they often never realize the difference that skin tone can make.

With identical light and background, the skin tone of the subject can make a difference in the background brightness. A fair person will have a very dark background (A) and a person with a dark complexion will have a very bright background (B).

■ The Separation Light

Because corrective lighting relies on a higher contrast lighting (heavier shadows and darker tones in the back-

ground), you must use separation, but only in the areas of your client you want separated. In all portraits, we use a hair light which is a small striplight overhead. Since this light is aimed back toward the camera, it meters one stop less than the main and yet provides a soft highlight on the top of the subject's hair and shoulders.

For clients with long hair, there are two lights near the back wall of this low-key area. Each is at a 45-degree angle to the subject. These lights are set to meter at the same reading as the main light for blonde hair or lighter clothing, or to one stop more than the main light reading for black hair and clothing. These accent lights are also fitted with barndoors to keep the light from hitting an area of the subject we don't want to illuminate.

Using darker backgrounds means that you will often use a background light to separate the subject from the background. Where the background light is directed and the intensity of the light will greatly determine what part of your client is separated. Keep in mind that this will draw the viewer's eye to that part of the body. With the background light low and the subject standing, you separate the hips and thighs from the background (the same hips and thighs that you know your client will worry about looking too large). By raising the background light to waist-height, the waistline and chest area are separated and become more noticeable.

Use separation light to accent only the parts of the client you want to draw attention to. Three variations are shown here, with separation light on the head and shoulders (A), upper body (B), and lower body (C).

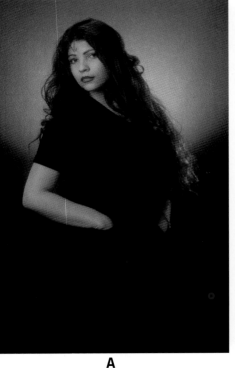

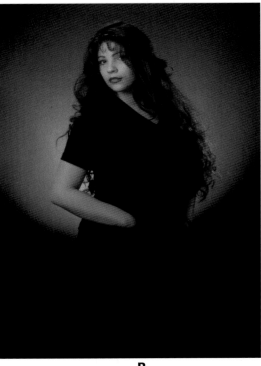

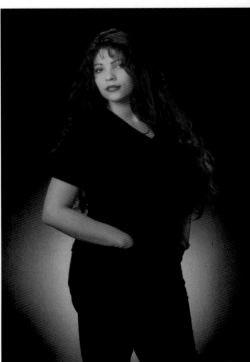

A B C

A

B

Elevate the separation light to the height of the shoulders and only the head and shoulder will be separated, leaving the body to blend with the background.

The greater the intensity of the background light, the more attention it draws to whatever part of the body it is separating—unless the subject is wearing lighter clothing. Often a client will select a dark background and want to wear lighter clothing with it. In this situation, by increasing the background light to match the brighter tone of the outfit, you will actually lessen the attention that is drawn to this area.

The idea is that you don't want to see a perfect outline of the body in an area that is a problem. For very heavy people, you don't want to see an outline of the body at all. This is also where you get into the coordination of light background to light clothing, and darker backgrounds to darker clothing. By coordinating the tone of the clothes and the background, you can bring the focus of the portrait away from the person's body and to his or her face. If you create contrast between the clothing and background, you can attract attention to the subject's body.

Creating contrast between the clothing and the background draws attention to the body (A). By coordinating the tone of the clothes and the background (B), you can bring the focus of the portrait away from the person's body and to his or her face.

Vignettes

We use a bellows-type lens shade on every camera. This type of bellows shade allows us to use vignettes (A). Vignettes do two things. First, they hold the viewer's attention by eliminating lines that lead out of the frame. Second (and most importantly) they allow you to fade off portions of a portrait that might not be flattering to a subject (B and C). This can be anything from a heavy thigh or arm, to the bottom of feet which may not be clean.

The vignette itself we make from plastic water bottles. We first cut out the plastic to fit into the shade (in the case of the Sailwind Shades, we attach the vignette using a magnet strip from the local hardware store). We then draw an oval in whatever proportion, in whatever area of the vignette we want on the plastic. We then cut this area out, zigzagging back and forth across the line to produce the teeth. The longer the teeth, the more gradual the effect of the vignette.

For working with low key portraits, we paint the vignette matte black. For high key portraits, we leave the plastic as it is. The material of the vignette matte is translucent, so to make it whiter, you just let light hit the vignette. Without light, the vignette will appear a light silver. We also buy the uncut, clear crackle vignettes which are nice for high key portraiture.

A

Since the Lindahl and Sailwind have no adjustments to move the vignette up and down or side to side, you must cut the opening in the various places that you position your subject in the frame. You also have to make different sizes of openings, to increase or decrease the effect of the vignette. These shades do allow you to extend the vignette farther from the lens to increase the effect, but with diffusion you end up seeing the outline of the teeth on the portrait if you extend the bellows too far from the lens.

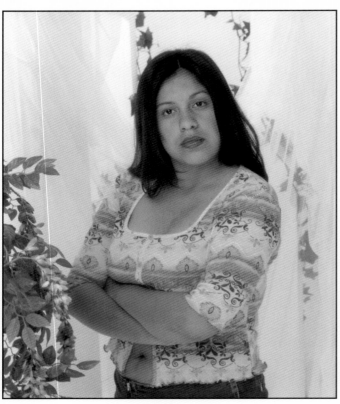

B

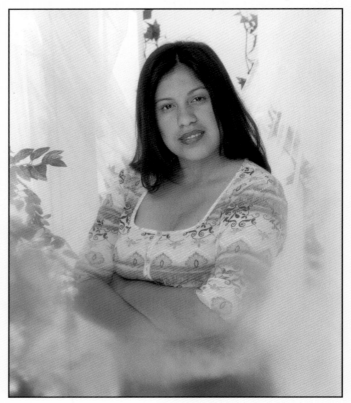

C

Whenever weight is an issue and the subject has long hair, we leave the background texture as dark as possible and put a light directly behind the subject facing toward the camera to give the hair an intense rim light all around the edges of the hair. This draws the attention directly to the facial area and keeps the viewer's eye away from the shoulders, arms and upper body.

■ **Positioning the Lights**

The angle of the main light is always determined by the orientation of the subject's nose. With the subject's nose pointed directly at the camera, the main light should be at approximately a 45-degree angle. To add shadow or bring out more facial structure you may increase the angle of the light, but this is the angle at which most portraits will be taken. The great thing is that the light always stays at a 45-degree angle to where the nose is pointing. Even when you go to a profile, the light still remains at a 45-degree angle to the direction in which the nose is pointing.

If you aren't good with angles, you can figure that with the nose pointing forward, if a line were drawn out directly from the ear, that line would be at a 90-degree angle (or one quarter of a circle, which is 360-degrees). In this same situation, if there were a line coming directly out from the edge of the subject's cheek bone, that would be a 45-degree angle. As long as the light stays at approximately this angle, no matter where the nose is pointed, the effect on the face and eyes will be beautiful.

Once the main light is in position, you have to decide on how much of the shadow area needs to be filled. With a reflector as a fill, what you see is what you get. Start with no fill at all. If the portrait looks great, don't add any fill. Somewhere along the line, you were probably told (like I was) that you have to see some detail in the shadow area. Wrong! If a shadow that goes black is what makes your subject look his best, then that is the perfect lighting to use on that individual client.

Most of the time however, some fill is necessary to bring the shadows to a printable level. Start with the reflector far away from the subject, then move it progressively closer until you get the effect you want. Whether you use white or a soft silver reflector will ultimately depend on what you have on hand. I use a soft silver one and pull it out farther than I would have to with a white reflector.

"The angle of the main light is always determined by the orientation of the subject's nose."

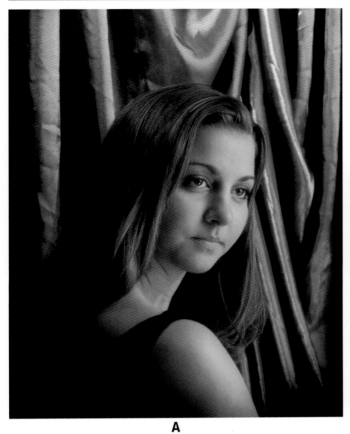

(Top & Bottom A and B) The main light should always be placed at approximately a 45-degree angle to the subject's nose. (Bottom A and B) Using a light box with a recessed face helps reduce light spillage and provides better control.

A

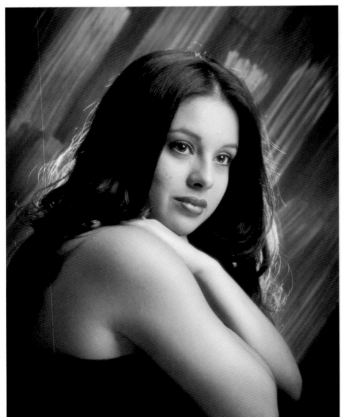

A

B

B

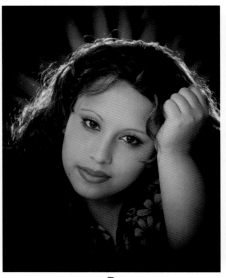

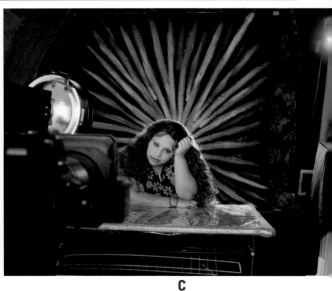

A B C

With the main light and fill reflector in place, separating the subject from the background becomes the next step. Again, there are no rules. You have one objective and that is to make your client look as good as possible. Remember, no background or separation from the background means no point of reference behind the subject. No point of reference behind or in front of your subject means no depth in the portrait.

For separation we have a strip light attached to the ceiling in our low key and yearbook area. This gives a soft separation to the hair and shoulder when the light is metered at one stop less than the main light. When the client has long hair we typically use two accent lights mounted on the back wall at about 6-feet high. These are angled inward at a 45-degree angle to the subject. This light adds a lustrous look to the sides of the hair.

To finish the separation, we add a light which we refer to as a halo light, that is aimed directly toward the hair behind the subject. This creates an intense rim light all the way around the hair. The side accent lights meter the same as the main (lights tend to pick up intensity when aimed back toward the camera). The intense halo light meters one stop more than the main for blonde hair to three stops more than the main for thick, brunette or black hair.

The last step is to add separation light. With dark hair on a dark background (as in the examples above and on the opposite page), it shouldn't be used. Adding separation lighting in this case will cause the hair to lose the impact it has against the darker background. With all this light on the

Image A shows the client in short sleeves. By framing the portrait to include just the head and shoulders, then using a grid spot and dark vignette to focus attention on the face (C), you can create a salable portrait (B).

hair, the subject doesn't need that much separation. This type of portrait is simple, but vary salable, for it gives any client a version of reality they can live with.

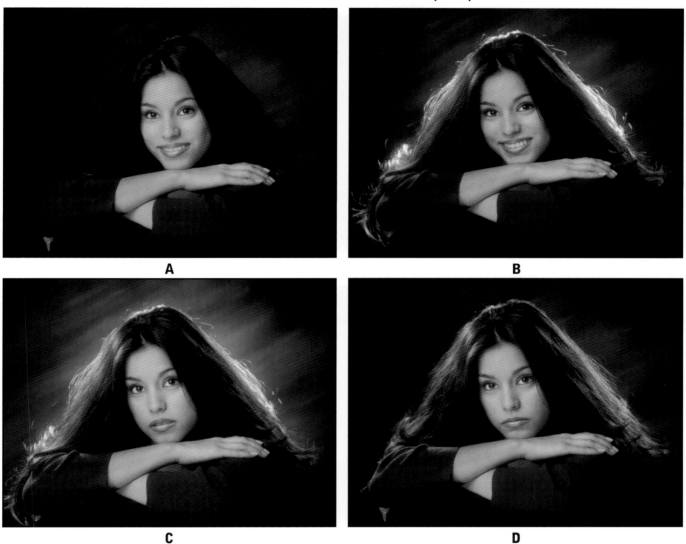

A

B

C

D

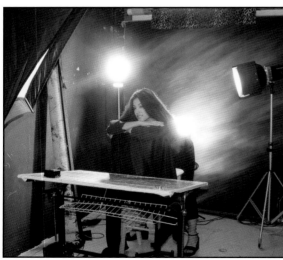

E

The number one complaint from clients with dark hair is how, in many previous portraits, they seemed to blend into the background (A). With all clients who have hair (not bald), we typically use a strip light overhead to add soft separation to the head and shoulders. For someone with long hair like this, we add two accent lights with barndoors at a 45-degree angle, and a final light is placed directly behind the subject's head. This light is angled back through the hair toward the camera (we call it a halo light). This can cause stray hairs to become very visible (B). In Image C, stray hairs have been reduced by reducing the intensity of the halo light. Sometimes this isn't enough, and we eliminate the halo light (D).

Don't Create New Flaws by Correcting Existing Ones

As we discuss corrective lighting, we won't deal with the other aspects of correcting flaws (posing, clothing, background and sets). However, when considering how to light a portrait to correct flaws, you have to remember that often, by correcting one flaw, you can make another flaw seem more apparent. A good example would be a person with a wide face and a very large nose. You can thin the face by increasing the contrast of the lighting and creating a larger shadow area, but if you are not careful, you can also create more shadows on the side of the nose, drawing more attention to its size. The same thing can happen with a person with bad skin. The more contrasty the light, the more the skin's imperfections become visible (but this can be eliminated in retouching).

■ Lighting the Full-Length Pose

Ever since senior portraits became a hot topic in the early eighties, lecturers, authors and educators have hailed the offering of full-length portraits as one of the best ways to set your studio apart from the contracted studios. I feel that the full- or 3/4-length pose has been oversimplified and its importance overstated. Once again, I have never seen one of those photographer/lecturers stroll out with a model who is five feet tall with a tummy bulge and short legs.

Therefore, the first rule of full- or 3/4-length poses is that if there is any reason not to do them, then don't. ("Laziness" doesn't qualify as a valid reason not to do a full-length pose, however.)

Corrective lighting and posing can take a lot of time and effort, but that's what you get paid for. Using corrective lighting, selecting the proper background and clothing choice can do a lot to enhance a person's appearance, but if the subject has significant problems (60-100 pounds overweight, large scars from burns, etc.) no amount of enhancements can produce a salable portrait in a full-length pose.

The following images show examples of some of our portraits with full-length poses. Standing, seated and floor poses are all included in this section.

"... if there is any reason not to do them, then don't."

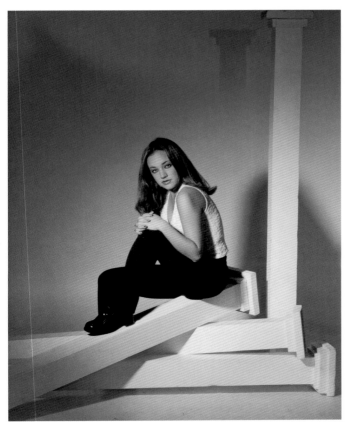

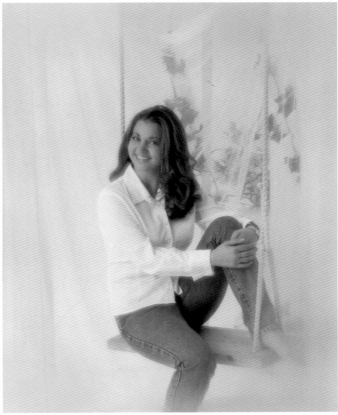

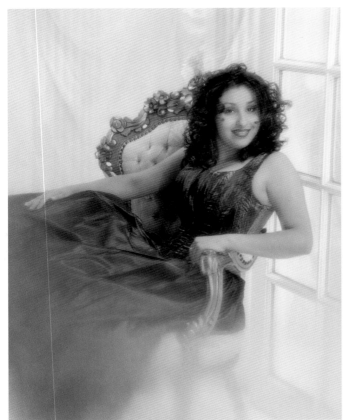

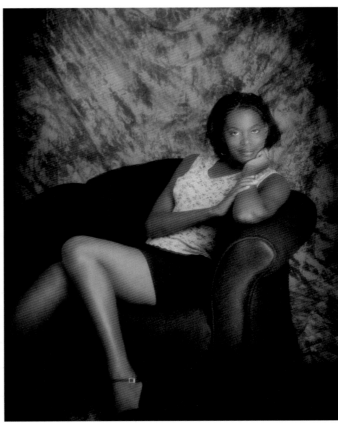

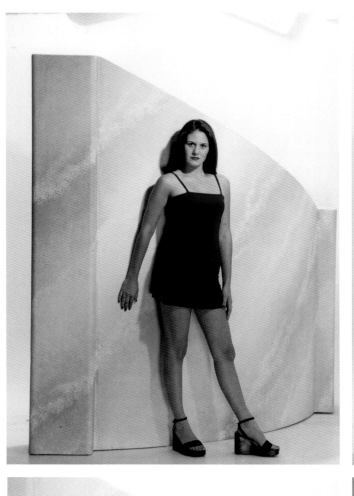
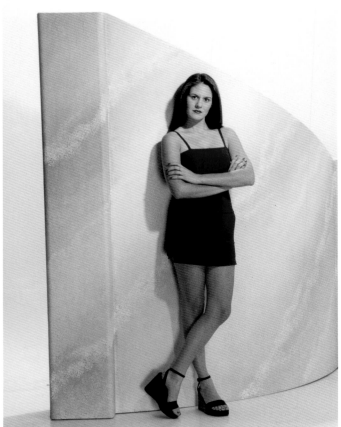
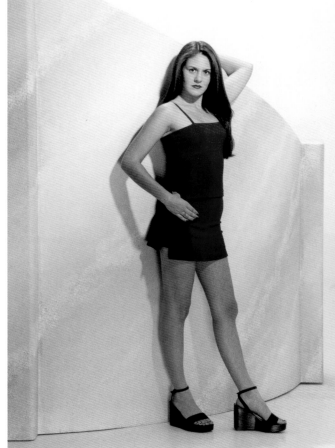
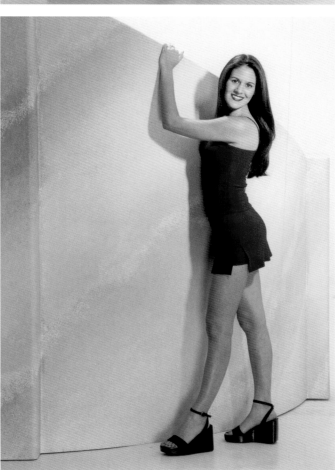

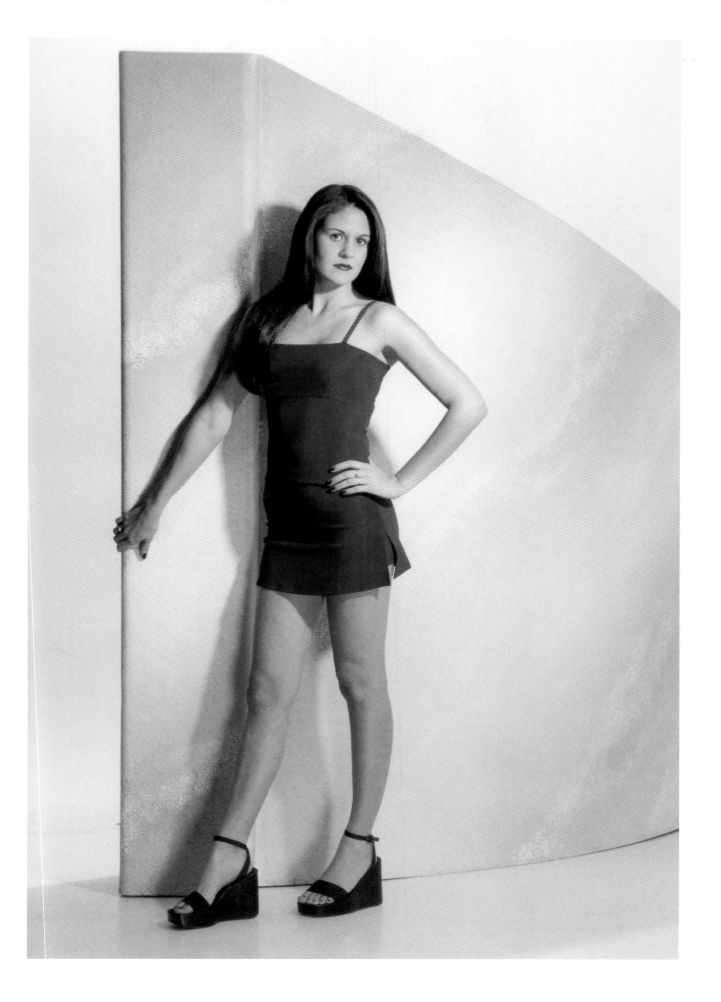

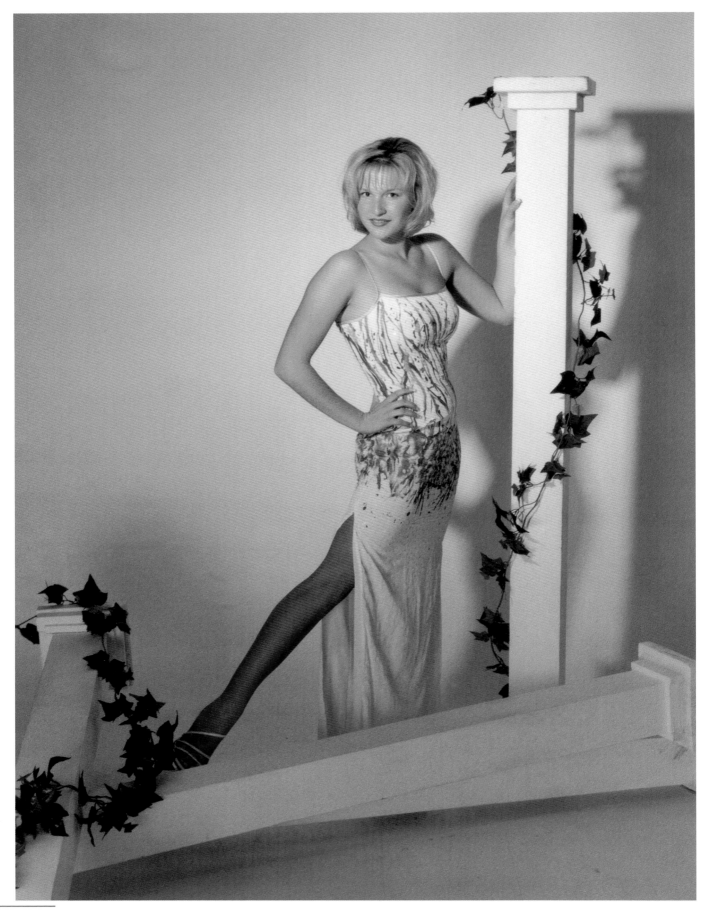

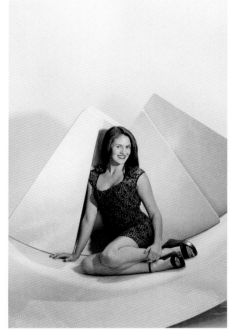

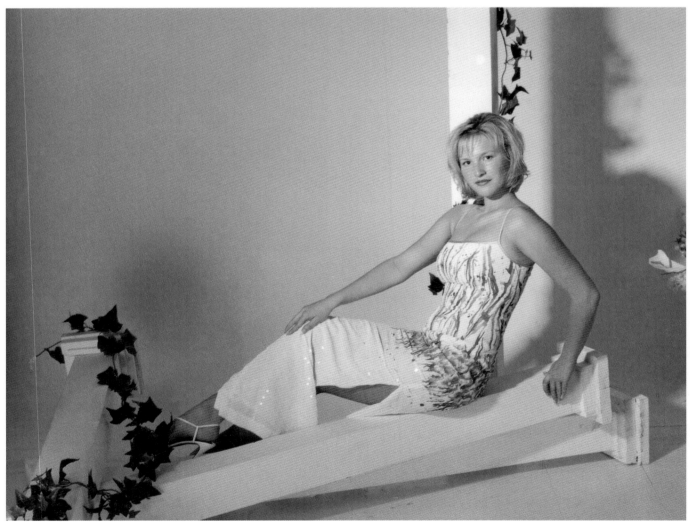

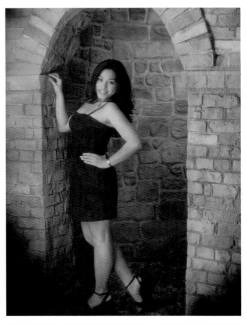

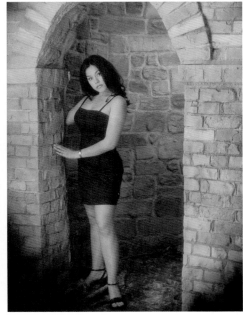

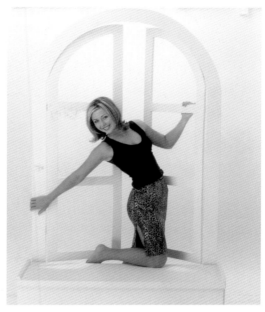
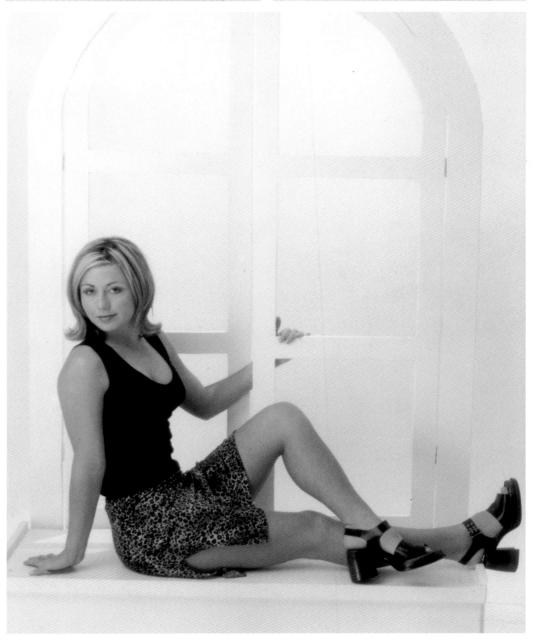

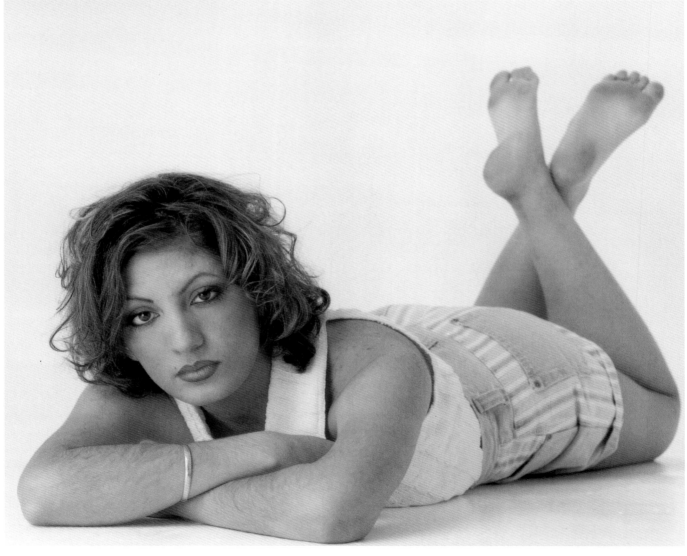

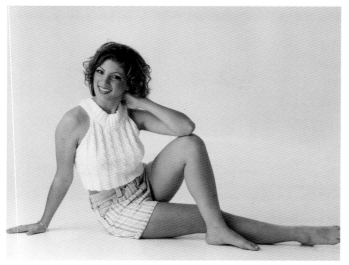 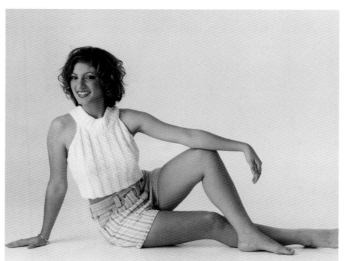

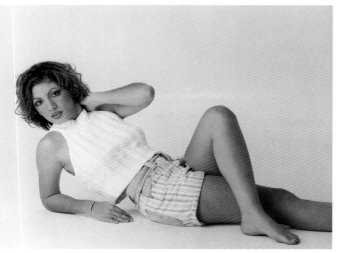 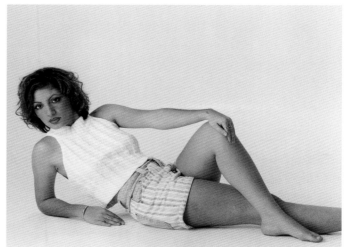

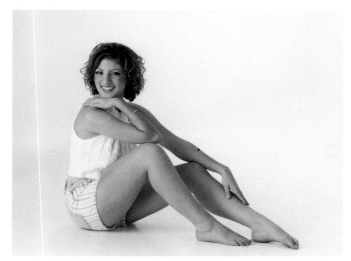 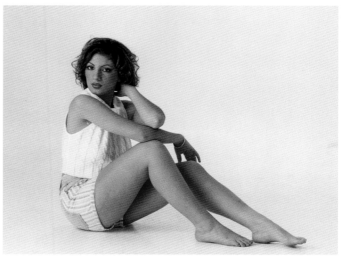

Low Key Set-ups. Corrective lighting for a full- or 3/4-length pose relies heavily on using light's fall-off to act as a vignette, thereby throwing certain problem areas into complete darkness and not allowing the camera to record the problems or flaws in those areas. The second lighting tool for correction is one we have already discussed—separation. By selecting what area of the body you wish to separate from the background, you determine which area of the body the viewer's eye will be drawn to.

A 24x36-inch louvered box may not be the first main light choice for the classic full-length portrait, but it is perfect for beautifully lighting the facial area and letting the rest of the subject fall completely into shadow. With this accomplished, you can proceed to add separation to the areas of the subject you feel should be seen in the portrait. This is no different for thinning a waistline than for concealing a balding head. You only separate the subject in an area that the client would want to see.

High Key Set-ups. This technique works well in a low key situation, but when you move to high key, lighting can do very little. Correction in high key portraiture relies on the clothing selection, the set used and the pose to make the subject look his or her best. As I have described before, we use a 72-inch Starfish and a 30x40-inch light box on the

> "... you determine which area of the body the viewer's eye will be drawn to."

A

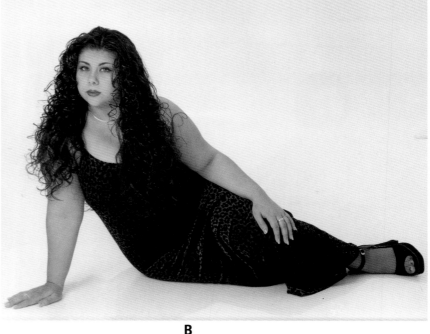

B

When the client's clothes contrast strongly with the background, it calls attention to the shape of the body (A). Careful corrective posing can still help to create a flattering portrait (B).

A

B

Adding a gobo restricts the spread of light. In this low key portrait (A) a gobo was used to block light from the lower part of the image (B), reducing the visibility of the lower torso and drawing attention to the subject's face.

floor. We use this for almost all the high key set-ups, when a softer looked is desired. We then use the other elements of the scene to hide the client's flaws.

In a high key head and shoulders pose, you can add a black panel to create more of a shadow, but in full-length poses you must rely on the pose, the clothing and anything else you can use to make the client look their best. Often, something as simple as a good pose and a client's long hair can be enough to make the subject happy with the way she looks.

In general, high key backgrounds, while very popular, are best avoided when it comes to anyone with a weight problem. With the softer, less contrasty look (provided by all the white walls filling the shadows) faces appear heavier and bodies wider. We have actually had many thin clients notice the difference between how wide their faces look on the high key backgrounds as opposed to their appearance on a low key set-up.

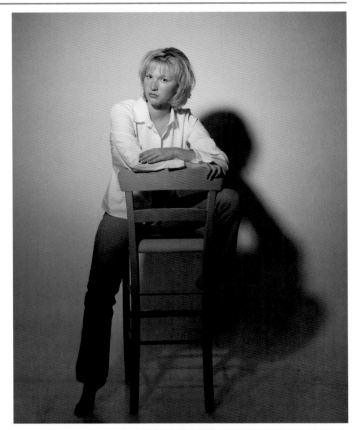

■ Grid Spots

In high school senior photography, the use of spotlights has been popular for many years, especially for portraits in black and white. The hard, contrasty lighting produces a very theatrical feeling. Spotlights also have the ability to focus the viewer's eye precisely where you want it to go. When used as a main light, the beam of the spot leads the eye to the facial area, while letting the rest of the body fall off into shadow.

In the studio, we use grid spots in three different ways. Often, we simply use a single grid spot as the entire lighting for the portrait. A very popular idea for seniors is to set the subject up against a white wall and let the heavy shadow

A

of the subject projected on the wall provide a dramatic background. In using the grid spot as the only light source, you have to watch out for the creation of deep shadows on the face. While dark shadows look good in the background, on the face these heavy shadows can be quite unsightly. The easiest way to handle this is to turn the face more into the spot-

B

C

Image A (opposite) shows the use of a single spotlight as the only source of light in the photo. In image B (above), the main light was replaced with a grid spot. In image C (above), a grid spot was added on the subject's face as an accent light.

light and work with the spot at no more than a 45-degree angle from the camera. Using the spot in this way gives you the greatest contrast and the most options for hiding flaws.

The second way we use grid spots in the studio is to replace the main light with a grid spot. When we do this, we also continue to use the light from a lower angle (like a 30x40-inch soft box on the floor, as in image B, above). This

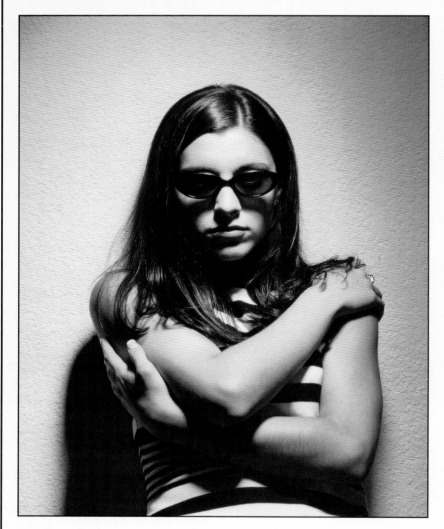

Black & White Portraits

When a client wants a black & white image, we don't use black & white film because of the cost of processing and printing. Instead, we use the Kodak 400 CN, a C-41 process film that produces true black & white results (with a little testing).

This film is much easier to work with than other C-41 black & white films of the past. Most labs will proof and print this film at the same price as color, which means you can provide black & white to any client without an additional cost—which adds to your sales and your profit!

In the black & white image shown here, a grid spot was used to create the dramatic, high-contrast lighting which makes the image so graphic.

lighting has a beautiful quality, but has more contrast than the 72-inch Starfish alone. It is also much more controllable. The grid spot is set to read at 1-1/2 to 2 stops more than the 30x40-inch soft box on the floor.

The third use for grids in the studio is as an accent light working with the main light to draw attention to the face. Simply put the sphere of light on the facial area after your normal lighting is in place. The spot should be 1/2 to 1 stop more than the main light, depending on how noticeable you want the light from the spot to appear. This little bit of light helps smooth the complexion, but more important is the effect it has on the color of the eyes. If you can see any color around the pupil, this accent light makes it much more vibrant. Anytime I see someone come in that has colored

"This little bit of light helps smooth the complexion..."

contacts or color around the pupils of their eyes, I do at least one of their poses with this accent light.

No matter how you use grid spots, they give you the ability to offer your client different styles of lighting that create different styles of portraits. A photographer that can only offer his clients one style of lighting, one style of portraits, can only appeal to one type of client, with one type of taste.

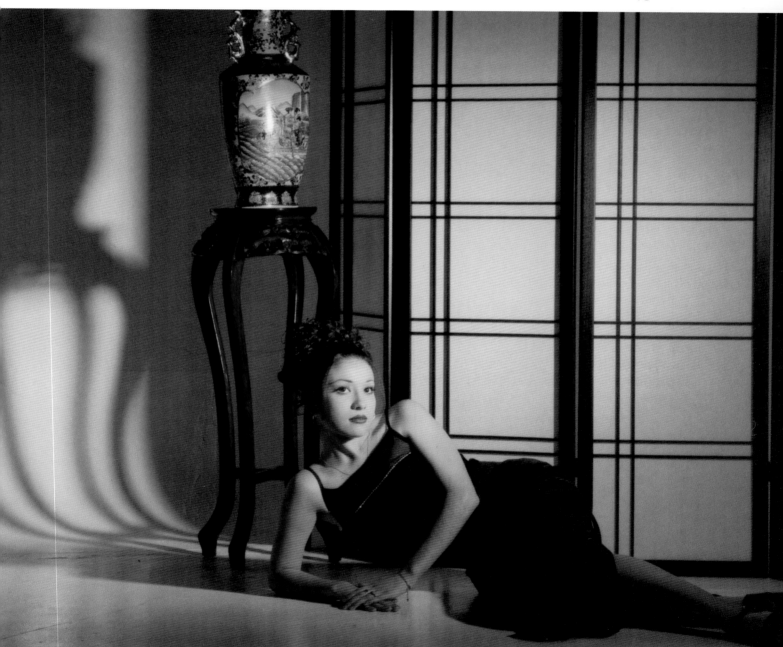

Grid spot lighting was used to create this full-length portrait.

5 Corrective Posing

■ Importance of Posing

Now that we have discussed lighting, we can get to the good stuff—posing. Posing is the most exciting part of what we as professional photographers do. A pose can make even the most basic type of portrait come alive. Other than the expression, nothing will sell more than the pose. Take whatever kind of lighting you want (professionally done, of course), then combine it with a flattering pose and you will satisfy your client every time.

Posing can do more to hide clients' flaws than any other method of eliminating problems—and probably as much as all of the others combined. Posing alone can hide almost every flaw that the human body can have. For every person, in every outfit, there is a pose that can make them look great. You just have to find it.

This leads us to the first part of corrective posing, namely, finding interesting poses to offer your clients. The second part of corrective posing is to convert the poses you find and currently offer into poses that will hide the flaws that a majority of your clients have.

Most photographers consider lighting to be their saving grace. If they just perfect their lighting enough, they feel that that alone will set them apart from the competition. I can tell you right now, if you follow the suggestions I am going to give you about how to find new ideas in posing, and if you learn to adapt them to your situation, you will do more to set your studio apart from the rest of the photographers in your area than lighting ever could.

"Posing alone
can hide
almost every flaw..."

■ Finding New Ideas

To find new poses to offer to your clients, you need only do two things. First, you must open your mind. Put out of your mind everything you have learned about posing. The posing manuals that we all learned from are completely outdated by today's standards. They will only make subjects look like the mannequins did in the department store windows in the Fifties and Sixties.

Forget about every joint being bent. Forget about the masculine and feminine tilts. Forget about the notion that many photographers have that for a portrait to have a "classic" or "traditional" look, the subject must appear as though they have a stick up their backside. We have all learned the rules, we have mastered the tilts, and now it is precisely this knowledge that stunts our growth.

The mannequin posing styles that were the rage in the Fifties, Sixties and even into the Seventies are completely unnatural in their appearance. I don't know about you, but I never stand somewhere and make sure that every joint in my body is bent. I am a man, I like to think a manly man, but I don't tilt my head in only one direction (always to my lower shoulder, according to the posing manuals). I sometimes don't cross my legs, and my hands aren't always in a fist, and never once in my life have I put my hand under my chin to rest on my thumb and index finger.

When all these rules that we learned were created, the times were different. Men were homophobic. If you didn't look like you had a stick up your backside, you looked like "one of them." Women were passive creatures, who stayed home and "tended" to their husbands and babies. Nowadays, men spend as much time on their hair and getting ready as women do. And if you don't think women have changed, you just leave the toilet seat up one time and see what happens. She'll give you "tended" to.

Some photographers are so stuck in what they have always done that they bitterly resist any change. I was once at a class on senior portraits. There was another photographer attending this class who was just starting out. Every time the photographer conducting the class wasn't talking, this photographer would ask me all kinds of questions. At lunch, we had some extra time so, with permission, I went into the camera room and started showing my new-found friend some of the different poses we use with seniors. He loved it.

> "Put out of your mind everything you have learned about posing."

Everything was going fine until the photographer conducting the program came in. I was doing a yearbook pose that had the subject reclining back, to make the shoulders run diagonally through the frame. The photographer conducting the class remarked that this was a pose more suited to boudoir than seniors. To reply, I simply asked both photographers if the subject looked beautiful in the pose. They both responded affirmatively. I said that was all that mattered.

The moral to the story is that people just want to look great. They want to look natural or glamorous—not like mannequins. Women are not passive, so don't do passive head tilts—just make them look good. And by all means, it is all right to take the stick out of the guy's backside and have him bend a little.

Step one (opening your mind) can be difficult, but step two (finding interesting poses) is easy. Just remember one word—plagiarize! There is no copyright on good ideas. There is no way that you, as a business person, have enough spare time to do sufficient test sessions to come up with all the new ideas you need in posing. It takes enough time to adapt the new posing ideas into practical poses that will work for your clients and hide their flaws.

"There is no copyright on good ideas."

So where do you turn? If you are smart you start looking at the fashion magazines that are directed toward the market that you work with the most. For our studio, I look at *Seventeen* and *Sassy*, as well as *Cosmo, GQ* and *Mirabella*. Your clients might have older or (in the case of children) younger tastes and styles, but there is a mountain of creative poses each month in these magazines, and these can be yours for the price of a subscription.

If you work with ladies from high school seniors to adults and have problems with posing women for full length portraits, you need to get a Victoria's Secret catalog. Don't get the catalog to look at the ladies, but look at the poses the ladies are in. The photographers who work on catalogs like this are masters at making the human form look its best.

When you look through these magazines and catalogs, you must use your imagination. Naturally you are not going to be photographing a high school senior in lingerie, but the body can be posed the same way as in the Victoria's Secret catalog—the senior girl will just have more clothing on. For those of you who do glamour photography, your client will be in the same poses, only wearing less clothing.

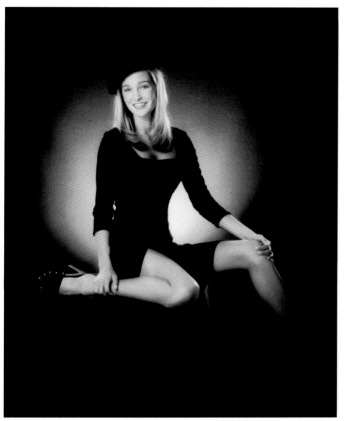
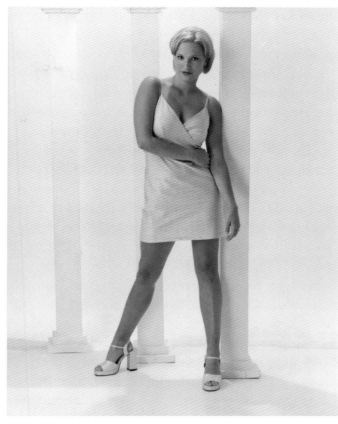

Look to magazines and catalogs as a source of posing ideas. These portraits were created based on clippings our clients brought in of poses they saw and liked in their own magazines.

To learn and become successful in a profession that is as competitive as ours, you must learn to transform ideas that work from other areas in photography (and even in other professions) and make them work for you. Some of our staff photographers also work on their own doing weddings and various other types of photography. Every time there is a wedding or children's seminar, I will ask them if they want to go with me. They laugh. They remind me that I specialize in nothing but seniors, but I always tell them, if I can get one usable idea for my business or my photography it is worth the time and money spent.

Never take things at face value. Make yourself responsible for adapting a good idea to fit your needs. The most unhappy and unsuccessful people in any profession, and in life in general, are the ones who consistently look at new ideas and say that they won't work. The happy and truly successful people in the world look at new ideas and think, "It could work—but I can make it even better."

We have taken the idea of gathering poses from magazines one step farther. In our studio information, we ask that each senior (if they wish) to bring in the poses they see in magazines that impress them the most and we will duplicate

the poses for them. This gives us a constant supply of new poses and, even better, they are poses selected by our target market. This tells us exactly what our specific clients want.

For some photographers, getting rid of old poses and ideas is harder than coming up with new ones. In addition to getting input from your target market on what they want, you also need to find out what they don't want.

In our studio, I pride myself on keeping up with the trends and staying current on the latest styles. I never will forget back in 1990 when a senior girl was looking through the sample books before the start of her session. She was making favorable comments about the portraits and showing us the poses and backgrounds she wanted done in her session. Her mother came across a background that had a fuchsia gel on it. The mother liked it and showed the senior, who said, "Oh Mom, that's so Eighties!"

I almost fell off my chair. After the shock wore off, I could see what the young lady was saying. Although colored gels were still being requested, these bright colors looked like the millions of other senior portraits that had been done in the Eighties. Even the photographers who were taking the grammar school kids' photos were already growing tired of the colored gels. After the session was over,

"This tells us exactly what our specific clients want."

We ask clients to bring in magazine clippings of poses they like, and then use the posing ideas in the client's portrait session.

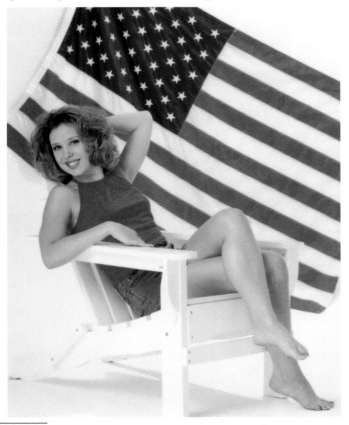

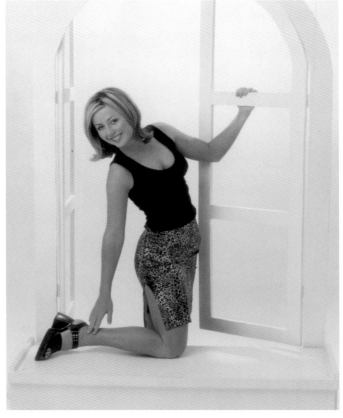

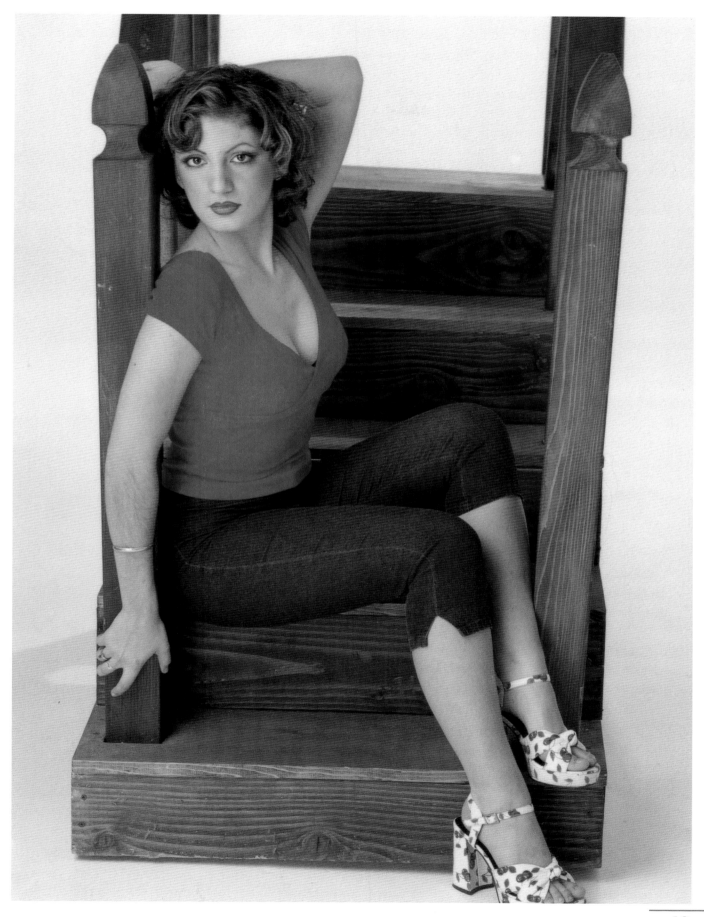

I removed all but two of the bright-colored backgrounds from the sample books.

Many photographers would have thought to themselves, "If I take all these out, what am I going to replace them with? Where do I go from here?" All of us love security. We like to know exactly what to do and not have to shoot from the hip or think on our feet. We are always afraid that when we throw something away we may not have what it takes to fill the void that it left. I knew that in a short time, the sample books would be filled with new ideas. To this day, we still have clients who request colored gels on the backgrounds. The colors are usually more subtle, but clients request them, and that is their choice.

Nothing stays in the sample books or on the walls of the studio for more than one year. I repaint at least 30% of my backgrounds every year, and try not to keep any sets more than three years. I make it my goal to paint at least two new backgrounds, design one new set and have at least two uninterrupted test sessions each month. Seniors are the most style-conscious type of client, but all photographers need to

"Nothing stays in the sample books... for more than one year."

Targeting Test Sessions and Displays

If a majority of the money in your pocket is made from weddings, the majority of portraits on display in your business should be weddings and a majority of the test sessions you do should be scheduled with a bride and groom. The same is true for families, children and seniors.

I have visited so many studios that make most of their living from weddings yet show black & white portraits of aspiring of models all over their studio. I know of some photographers that work with mature clients in a variety of situations (families, business portraits, weddings, etc.) and when they do a test session it is always of a young woman in swimwear or lingerie. This, first of all, is a little creepy and probably why so many photographers get a less-than-sterling reputation. More importantly, it does you and your business no good.

You can't learn to work more effectively with one type of client by photographing another.

force themselves to bring new ideas into their studios regularly, and to throw out some of the old ones.

■ Test Sessions

The easiest way to come up with new ideas is by photographing subjects who are not clients and testing out new ideas on them. The problem that most photographers have is that they don't plan the test session. They have a person come in to the studio and plan on "winging it." They think to themselves that working off the cuff will raise their creativity. Yeah, right! If you don't plan for your test session, you will feel the pressure of trying to be creative and come up with something new on the spot. You will end up doing variations on what you already offer, which gets you nowhere.

When you schedule a test session with a subject, plan for it. Gather together the clippings clients have given you, as well as those you've collected yourself from magazines, books and other sources. Make yourself a checklist of how many new ideas you want to try, and what changes you want to make to each of the ideas you have clippings for. As I said earlier, rarely do ideas spring up fully formed and ready to use in your situation. You have to make alterations to the ideas so they fit your studio and your client's taste.

■ Categories of Poses

Poses basically fall into two categories, the fashionable and the casual. In magazines, fashion catalogs, CD covers, etc., you will get ideas that are fashionable. These ideas are meant to make the person attractive to the opposite sex, which is important to almost all of your clients. The casual poses are poses that are taken to achieve a more wholesome feeling (say, a portrait of a senior for Dad's desk, a portrait of a mom for her son, a child for his or her parent). This type of portrait captures the feel of the person at home, where he or she is relaxed and comfortable. Since that is the look you want to capture, keep your eyes open at your own home for ideas on how to pose your clients. I can't count the number of poses I have come up with just by being observant and watching my wife and children relax.

Study the people that are the age of your clients, as they watch television, listen to a conversation, talk on the phone or have a picnic. Study how they fold their legs, the place-

"Poses basically fall into two categories, the fashionable and the casual."

A

B

C

D

ments of their hands, how they support their heads with hands, arms and shoulders. As you start looking, you will see that finding unique poses is the easy part—poses are all around you—it is remembering them that is difficult, so write them down.

■ Adapting a Pose to Hide a Flaw

We have already looked at the typical flaws that both men and women have. Now all you need to do is adapt your poses to cover, disguise or cast a heavy shadow on the areas of the body and face that are problems. Many of the more relaxed poses that you will find already hide some of the most annoying problems that your clients have.

Double Chin. A double chin, or the entire neck area in your older clients, is easily hidden by resting the chin on the hands, arms or shoulders. As the chin lowers on top of the part of the body supporting it, the entire neck area is hidden. Be careful that the subject barely touches his or her chin down on the supporting element. Resting on it too heavily will destroy the jaw line. For a selection of poses which hide this area, see the illustrations on the opposite page and refer to pages 8-9.

Another way to make a double chin and loose skin on the neck easier on your client's eyes is to stretch the skin under the neck. To do this, turn the body away from the light, then turn the face back toward the light. This will stretch out the double chin so that it will not be as noticeable.

When a head and shoulder pose is needed (for yearbook, business publication, etc.) it is sometimes impossible to use the hands or arms to hide this problem area. Posing the body to make the neck stretch can only do so much to hide a large double chin. In a case like this, you do what some photographers call the "turkey neck."

The turkey neck means simply extending the chin directly toward the camera, which stretches out the double chin. You then have the subject bring down their entire face to the proper angle, over the double chin. Normally (without extending the chin forward) as you have the subject bring down his chin to achieve the proper pose, the chin comes back to the neck, making the problem much worse. Most of the time this turkey neck maneuver eliminates the double chin from view. The technique is especially helpful when photographing a man who is wearing a collared shirt and tie.

"A double chin... is easily hidden by resting the chin on the hands..."

(Opposite, A and B) Resting the chin on the hands, arms or shoulders can conceal the chin area. (Opposite, C and D) To stretch the skin under the neck, turn the body away from the light, then turn the face back toward the light.

A

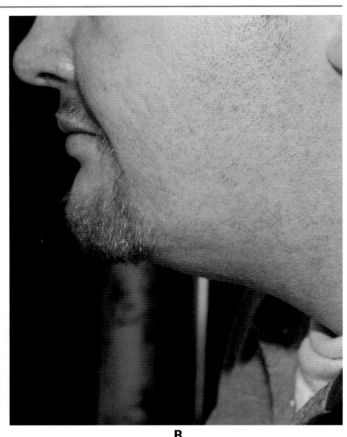

B

Men who have large double chins often also have tight collars, which push up the double chin and make it even more noticeable.

The neck area can also fall prey to "man-made" flaws. When working with high school seniors, sometimes you have to deal with little surprises left by an overzealous partner. The young lady shown in the pair of photos on the opposite page was ready to have her yearbook portraits taken when I spotted the little "surprise" on her neck. A turtleneck sweater would have been a better clothing choice for the portrait, but unfortunately we were photographing her for the yearbook at the high school and this was her only clothing option.

The first time I had to deal with this, I photographed the senior thinking that the discoloration could be retouched. My lab explained that the entire area of the print had to be made opaque (almost white). Then the area would have to have artwork done to make it flesh-tone again. The whole process took a lot of time and cost me a lot of money.

To hide this young lady's affliction, it was simply a matter of using her chin to hide the neck area. The first step was to raise the camera angle to a point that the chin could

Minimize the appearance of a double chin (A) by having the client stretch his chin forward (B) to stretch out the skin.

obscure the neck area. Then we moved the light to the same side of the subject as the problem area was on, so the young lady's face would be turned toward the light, placing her chin directly over the unsightly area. A large "Adam's apple" can be concealed in the same fashion.

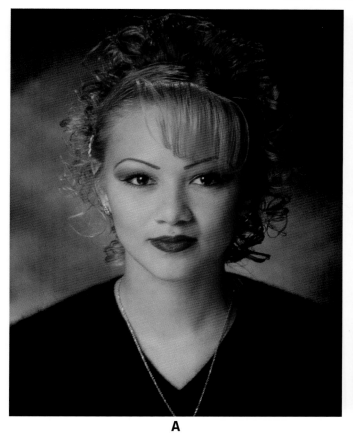

A

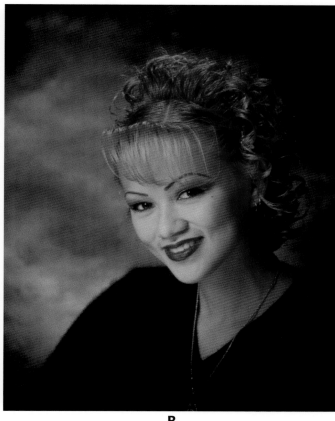

B

Rather than using costly retouching to correct the discoloration on this young lady's neck (A), the camera was elevated to allow the chin to cover the neck area and the subject posed so the area to be concealed faced away from the camera (B).

Ears. Corrective posing is also the best way to combat the problem of ears that stick out too far, a problem that occurs when the trends in hair styles are short. Ladies who have a problem with their ears usually wear their hair over their ears. In this case, make sure that the subject's hair isn't tucked behind her ear, as this will make the ears stand out. Larger ears can also stick out through the hair making them appear really large.

The best way to reduce the appearance of the ears is to turn the face toward the main light to a point where the ear on the main light side of the face is obscured from the camera's view. Then, either move the fill reflector farther from the subject to increase the shadow on the side of the face where the other ear is showing, or move the main light more to the side of the subject to create a shadow over the ear.

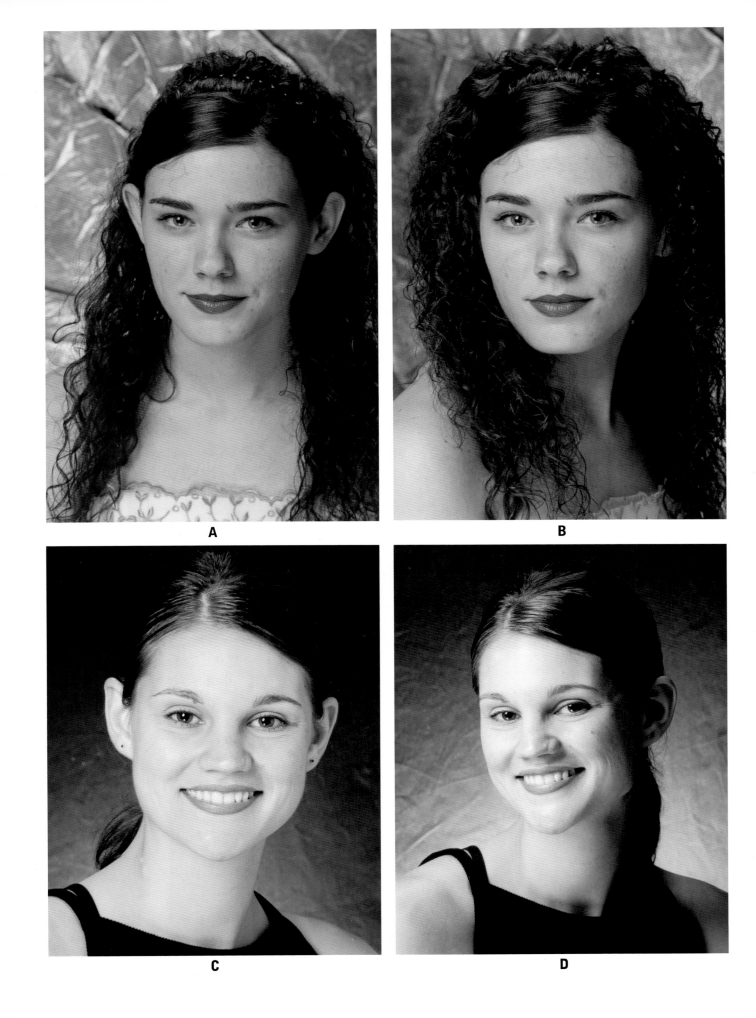

A

B

C

D

(Opposite A and B) For clients with long hair, bring the hair over the shoulder and around the face to make the ears less visible. (Opposite C and D) For other clients, turn the face toward the mainlight to obscure the far ear, then reduce fill light on the shadow side to obscure the other ear.

Reducing the separation between the subject and the background in this area should also be used to make the outline of the ear less visible. Overhead hair lights should be turned off so as not to highlight the top of the ear.

In a situation where the ears are so large that they can't be hidden in this manner, you have two choices: either let the ears be seen, or highlight only the "mask" of the face, letting both sides of the face fall into shadow. This is the type of lighting that Marty Richert made famous years ago.

Noses. The nose is only seen in a portrait because of the shadows that are around it. By turning the face more toward the light or bringing the main light more toward the camera, you can reduce the shadow on the side of the nose, and thereby reduce the appearance of the size of the nose.

Butterfly lighting, which is using the main light directly over the camera and a reflector underneath the subject can also reduce the apparent size of the nose. This type of light-

Butterfly lighting can reduce the apparent size of the subject's nose.

ing compacts the nose by completely eliminating the shadows on each side of the nose. The only shadow that appears on the face is the butterfly-shaped shadow that appears under the nose, hence the name.

Shininess and the strong highlight that runs down the nose on shiny skin also draws attention to the size of the nose. Usually, this is only a problem with guys, or when you are working at an outdoor location and it is warm. Ladies usually wear a translucent powder that eliminates this shine. By keeping a few shades of this powder in your camera room, as well as with you at locations, you can save yourself a great deal of time in retouching.

Eyes. Eyes are by far the most important part of a person's appearance. The eyes can make the person look alive, or void of all feeling. The eyes must have a nice catch light, which we have already discussed in corrective lighting. Corrective posing can help a client who has eyes that are either too small, or too large.

Most people want their eyes to look as large as possible. By turning the face to the side (toward the main light) the center of the eye goes more the corner of the eye opening and gives the eye more impact, as well as a larger appearance.

With a person with larger eyes that tend to bulge, the face needs to be directed more toward the camera. In a person with eyes like this, turning the face and bringing the center of the eye to the corner of the eye opening shows way too much of the whites of the eye. Instead, as you pose and adjust the lighting for a person with large, bulging eyes, you need to make sure that no catch light is on the whites of the eye. If a catch light records on the white of the eye, it will draw a great deal of attention to this area, as well as become much too bright.

Making the eyes appear alive and beautiful is the single most important part of any portrait. The most frequently made mistake of young photographers is lighting and posing a portrait primarily to bring out the structure of the face. Instead, the priority should be to ensure that the subject's eyes have beautiful catch lights in them. When I have to talk with clients about re-taking photographs that one of my photographers has taken, the eyes are the first place I look. I usually find that the clients can't pinpoint exactly what they don't like about the portraits. They say they just don't look right, they don't look like themselves or they don't look happy and/or alive. Then I know it was the eyes.

"Most people want their eyes to look as large as possible."

Turning the face toward the main light and directing the eyes back at the camera reveals more of the white of the eye, making the eyes look larger.

In most the cases, the problem is simply a matter of the main light having been positioned too high. Control with corrective lighting requires more skill, more time and more concentration. You must position and re-position each light, each reflector, and each gobo every time you change the pose in any way. Although your primary goal is to correct flaws, you must start with the eyes. If the eyes aren't lit properly, no matter how many flaws you correct, the portrait will look lifeless.

In addition, I never have any subject look at an inanimate object (at the camera lens, wall or light)—they are always looking at a person. This makes the eyes more alive, for there is someone there to connect with. Eyes that seem to be looking directly at the camera have a more intimate look, simply because the subject's eyes seem to make direct contact with the viewer. The subject is still looking at me, but my eyes are directly on the side of the lens. The rest of the "look" of the portrait comes from the expression. With

A

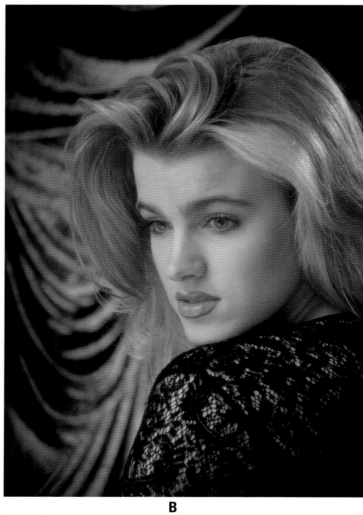

B

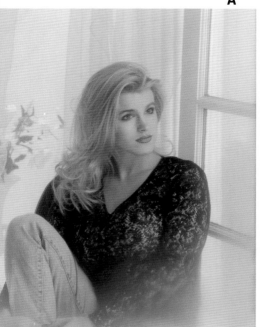

C

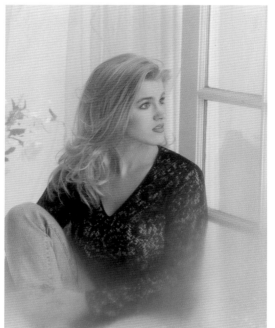

D

E

(Opposite, A) Turn the eyes toward the camera for a more direct look. (Opposite, B) Turn the eyes away from the camera for a more reflective look. (Opposite, C) For reflective portraits, the eyes should follow the line of the nose. Avoid allowing the subject's nose to go past the line of the cheek that is farthest from the camera (Opposite, D). When the eyes don't follow the nose, the subject looks as though she was distracted just before you clicked the shutter (Opposite, E).

direct eye contact and a separation between the lips, you achieve an alluring look. With direct eye contract and a smile, you have a portrait that looks alive and fun.

Portraits which have a more reflective look are basically images in which the subject does not have direct eye contact with the viewer. Many photographers have trouble making this look natural. The key to creating reflective portraits is in the eyes. First the eyes should generally be at an upward, rather than a downward angle. Many children's and brides' portraits are taken with a downward orientation of the eyes, making the subject appear to be chronically depressed. The eyes are the windows to the soul and these windows are closed when the eyes look down.

Second, the eyes should always follow the line of the nose. Many times, a photographer will have the eyes look farther from the camera position than the nose is pointing. The result is that the subjects looks as though someone called their names right before the portrait was taken and they didn't want to move their heads.

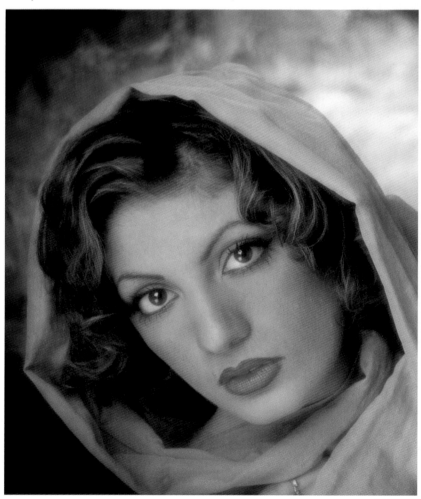

How well a subject's eyes reflect light depends on the person. Showing more of the white of the eye will make the eyes look larger.

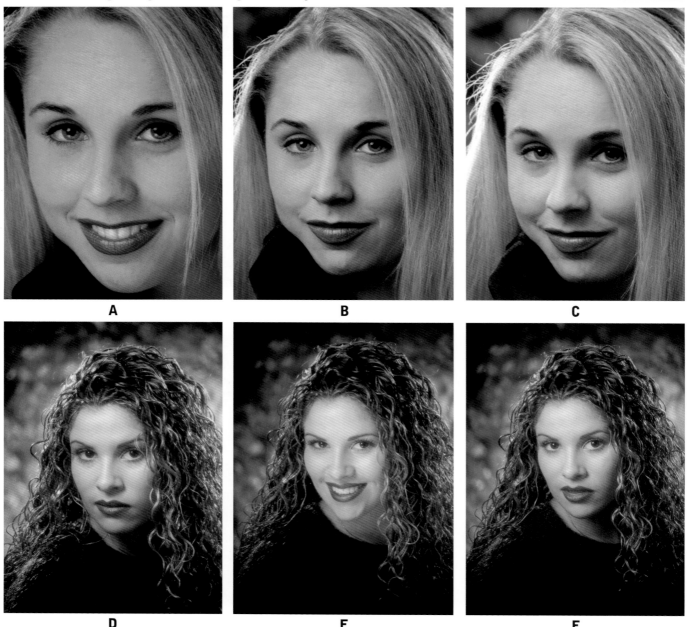

Finally (the golden rule that is often broken), you should never let the subject's nose go past the line of the cheek that is the farthest from the camera.

With the large light boxes and modifiers that photographers are used to, you can leave the light in one position for almost every subject. Working with the small 24x36-inch louvered box, the elevation of the box is different with each pose and every person. The smaller the box, the more you see how different people's eyes reflect light differently. How they reflect depends on the shape of the eye and eye socket, the individual's eyebrow line, as well as the make-up worn.

Which would you choose? In C and D, the main light is too high to properly illuminate the eye. This is what happens when you don't adjust the light for each pose of each client. In B and F, the eyes are lit properly, but the lighting lacks the style and glamour of A and E, where reflected light was added from the mylar top of a drafting table.

I have found the easiest way to achieve the perfect illumination with any light is to raise the light to a point that it is obviously too high, then slowly lower it until catch-lights appear in the upper eye and the lighting effect is pleasing to the contours of the individual's face.

Glasses. Glasses will always be a problem if you don't advise your clients to get empty frames from their eye doctors. The new non-reflective lenses make life a little easier, but anytime there is glass in a pair of frames, you end up lighting and posing the subject to make the glasses look good, rather than to make the subject look good.

In our studio, as I have said before, we always use a light or reflector under the subject to add a more glamorous look to the lighting, as well as to bring out more of the eye color and smooth the complexion. With any type of glass in the glasses, the light or reflector has to be removed or it will create glare.

Another technique used to reduce glass glare is to angle the frames of the glasses so that the lenses point slightly downward and the frame raises slightly above the ear. This usually reduces the glare and the change of angle isn't noticeable from the perspective of the camera. This isn't an ideal solution, but it is more manageable than spending a fortune on enhancement to remove the glare.

A second effective technique is simply to raise the main light to a point at which no glare is visible from the angle of the camera. Here again, though, you are creating the portrait to avoid glass glare, not to make your client look her best.

Glare from glasses is always a problem (A). One solution is to angle the frames so the glass points slightly down (B). From the perspective of the camera, this tilt isn't noticeable and eliminates the glare (C).

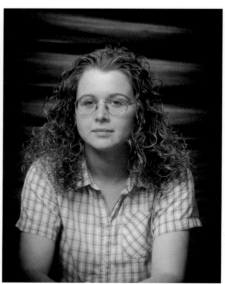

A

B

C



Expressions. Proper expression depends on the age of your clients. With babies and small children, parents love laughing smiles. With children, even moody, almost chronically depressed expressions are salable. In dealing with adults or near-adults, expressions are more subtle.

While squinty eyes are cute on a baby, not many adults really want to see themselves with no eyes, huge chubby cheeks and with every tooth in their mouth visible. Large smiles are not only unflattering to adults for these reasons, but also because this expression brings out every line and wrinkle on a person's face. Adults are always self-conscious about crow's feet, smile lines, and bags under the eyes—all of which are made much more noticeable by huge smiles. While retouching can lessen these lines on the face, the retouching often reduces the lines too much, making subjects not look like themselves.

Expression isn't your client's responsibility. As the photographer, you must develop a connection with your subjects that allows them to feel comfortable enough with you that they will "mirror" or reflect the expression that you have. When you want a relaxed, comfortable expression, you speak to your clients in a relaxed tone of voice, with a relaxed, non-smiling expression. When you want your clients to smile, you simply speak to them in more upbeat tones and smile yourself. The clients follow your lead.

As I have worked with many other photographers in our studio, I have seen clients get very frustrated when the photographer doesn't reflect the mood and expression that the client is supposed to have. We once had a photographer who was very calm and serious. He would tell seniors to look right at him and smile, while he had a poker-face. The seniors' expressions suffered because of it. Another photographer, who was always upbeat and laughing, had the opposite problem. I would see seniors get frustrated as they were attempting to achieve a relaxed, more serious pose, while the photographer was joking with them, having a big smile on his face.

Expression is, by far, the hardest part of any session for your client. From the day we start pre-school, we are tricked and teased into huge laughing smiles. We are told to say "Cheese," "Fuzzy Pickle" and even "Sex" as we get older—all to end up with portraits of ourselves that show us with our mouths wide open as we were saying the photographer's stupid word.

"Expression is, by far, the hardest part of any session for your client."

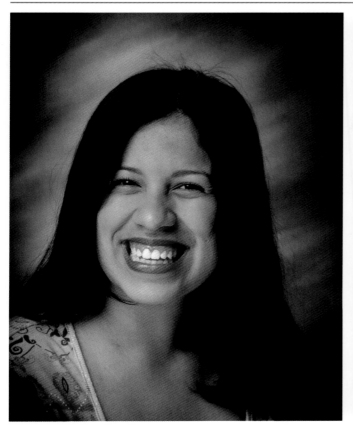

A

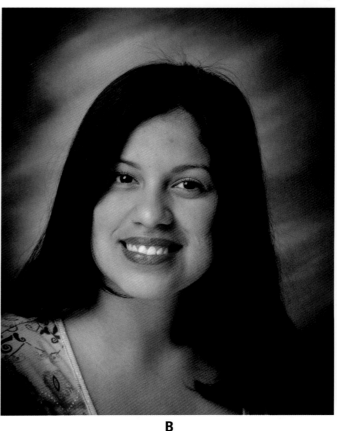

B

When most people first start to smile, it is enormous (A). A moment after a person smiles that laughing smile, the expression starts to relax (B). This is the expression adults prefer.

The only clients that don't have a problem with expression are the cheerleader-type girls or the few people that have that perfect "Colgate™ smile." Although these types of clients will smile easily, the smile can have a "pasted on" look—one without feeling or emotion. I call it a performance smile. If you've ever looked at cheerleaders or people in theater who have to hold smiles for prolonged periods of time, you've seen the performance smile. You see the teeth, but you don't see the emotion.

With smiling, timing is also important. It is easy to get a subject to smile, but once your client smiles, it is up to you to decide when the perfect smile occurs and take the pictures. When most people first start to smile, it is enormous. If you take the shot at this point, you end up with a laughing or almost laughing smile. Once your client has a smile like this, you must watch and wait. A moment after a person smiles that laughing smile, the expression starts to relax. It isn't that much, but it is the difference between a laughing smile and a smile that is pleasing to an adult client.

Thinning Hair. Men don't have a problem when they are bald by choice, but it is another thing entirely when you are dealing with a man who had no choice in the matter. We

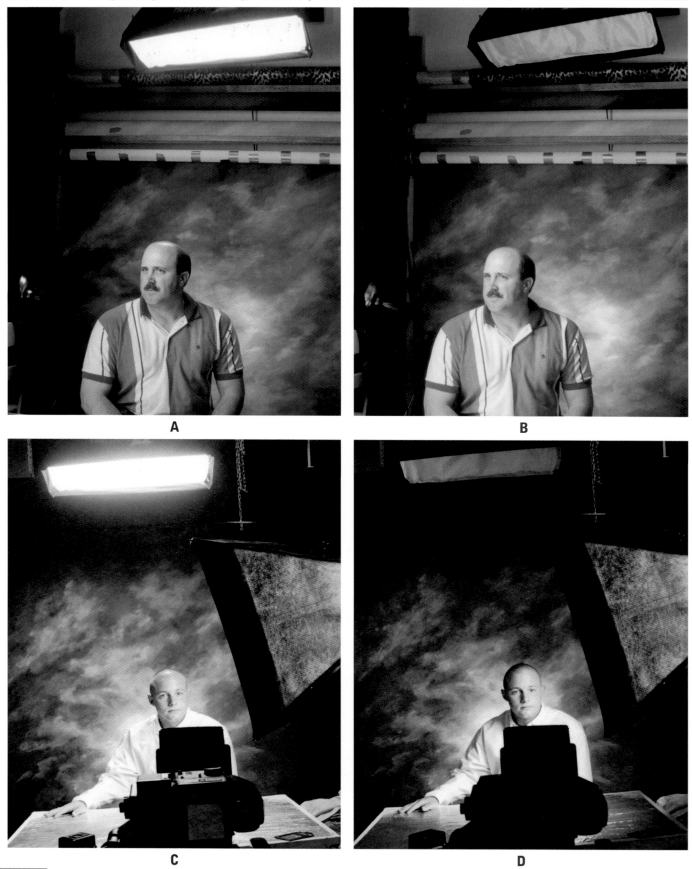

A

B

C

D

When photographing a subject who is bald by choice (Opposite, C and D) turn off the hair light to prevent the top of his head from glowing. Combine this lighting trick with a lowered camera angle to help disguise the problem for clients who are not bald by choice (Opposite, A and B).

have all seen the guys with six hairs on their heads who believe in their hearts that those six hairs can really cover the tops of their heads. Some woman today are also plagued by thinning hair which makes the scalp very apparent.

If clients are bald by choice, meaning they have decided to shave their heads, they will not usually be that self-conscious about it. To photograph them, simply turn off your hair light (so their heads don't glow with diffusion) and you will be fine. However, if a person's baldness is out of his control, no matter what he says, he is not altogether too happy about it. When you meet with a man over thirty who is wearing a hat or cap you can be 90% certain there is a bald head underneath.

To disguise the head without hair, you have two choices: you can use shadow, or buy some of that cotton-candy looking hair in the can (just kidding). To use shadow to reduce the appearance of the balding area, turn off the hair light and lower the camera angle slightly. Then, make sure that the separation light is low enough to just define the shoulders from the background but still allow the top of the head to blend in. At this point, the problem will be much less noticeable.

If a man is really worried about his lack of hair, you can lower the main light and use a gobo in front of the main light source to hold back some of the light coming from the top of the light modifier. They (and you) have to remember, this isn't an alternative for a hair transplant, though. It doesn't make a person appear to have hair, it just makes the problem less noticeable.

Arms. Most women worry about their upper arms appearing too large or about hair showing on their forearms. Men generally worry about their arms looking too thin or too flabby. The best way to avoid problems with arms is to cover them up with long sleeve shirts or tops. When short sleeves are worn, your choices are: compose the portrait above

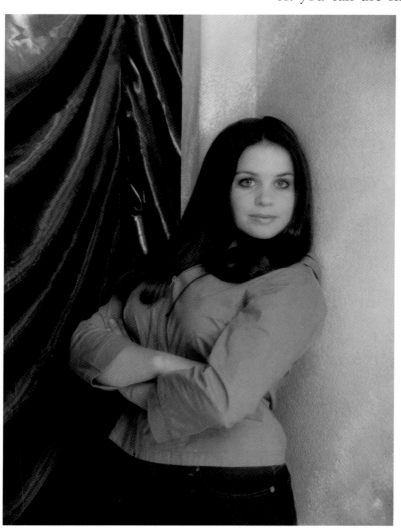

The best way to eliminate concern about the appearance of arms is to photograph the client in long sleeves.

the problem area; use lighting fall-off or vignettes to make the area darker and less noticeable, or if the client has long hair, use the hair to soften the problem area.

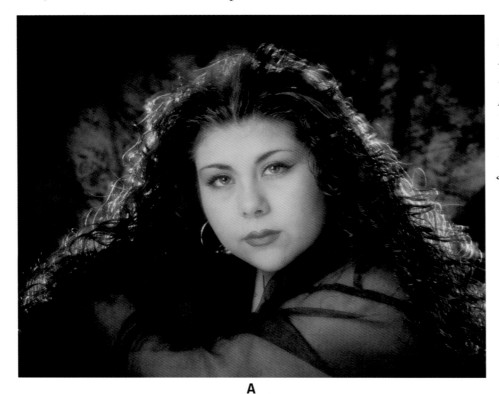

A

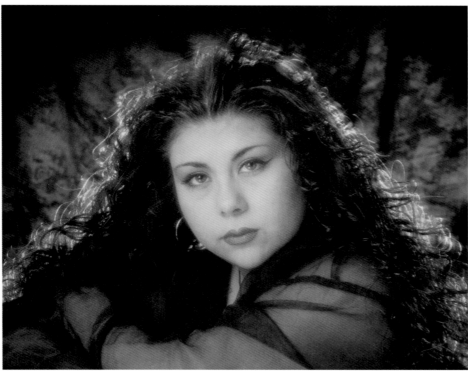

B

The client's sheer sleeves reveal too much of her arms (A). Achieving a more flattering look (B) was as simple as composing the image with a closer view. Notice how the subject's long hair was also pulled across her shoulder to help disguise the problem area.

Bustline. The bustline isn't a problem in most portraits, because the client isn't in low-cut clothing. You must always make sure that a client's bustline appears even, if it will be noticeable in the frame. When a low-cut top is worn, the size of the bustline is determined by the appearance of cleavage. Cleavage is nothing but a shadow. Increase the shadow by turning the subject toward the shadow side of the frame, and you will increase the apparent size of the bustline. There are times that a top is too low-cut for the type of portraits a client wants. By turning the client toward the main light, the shadow in the cleavage area is reduced.

Waistline. The waistline is the area that almost everyone feels is never thin enough. To make the waistline appear more slim, turn the client toward the shadow side of the frame. This works well as long as the person has a somewhat flat stomach. If you do this with a person who has a bulging stomach, you will put the bulge in silhouette. This is like doing a profile of a person with a big nose.

In a seated position, clothing and skin wrinkle over the waistband of the pants (A), giving even the thinnest person a roll. If the person is thin, simply have her straighten her back, almost to the point of arching it (B).

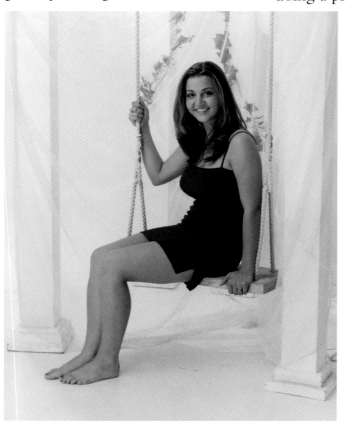

A

B

When someone does have a tummy bulge, the easiest way to hide the stomach area is to pose the client in a sitting position, then elevate the leg closest to the camera. This par-

tially obscures the stomach area. Having subjects rest an elbow on their knee (or knees) will completely hide this area.

The waistline really becomes a problem, even for thin people, anytime you have a subject in a seated position. Clothing and skin wrinkle over the waistband of the pants, giving even the thinnest person a roll, whether it be of cloth or skin. If the person is thin, simply have her straighten her back, almost to the point of arching it. If the person is heavier, you need to hide this area as described above.

Thighs and Legs. Thighs and legs need to appear as thin and toned as possible. Again, this isn't a problem for most men, because only athletic men normally ask to take a photograph in clothing that shows their legs or thighs. Women, however, are often told they should wear dresses, tight skirts and pants—even when it would be in their best interest not to.

When posing female subjects in a full length pose, I always have the person sitting or laying down. Unless a person is very tall and thin, she will always look better posed in

With feet flat on the floor, legs don't look their best (A). Lifting the heel flexes the calf and thigh muscles, making the legs appear longer and firmer. This can be accomplished by wearing high heels, or simply lifting the heel into the same position as if the subject were wearing high heels (B).

A

B

 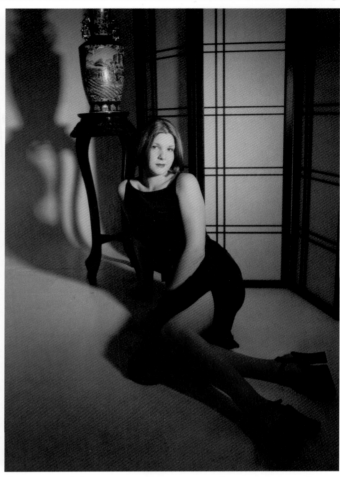

When the subject is posed with her legs toward the camera, using a wide-angle lens will make them look even longer.

this way. Whenever I have a woman seated, no matter how thin or heavy she is, I don't have her sit flat on her bottom. Instead, I have her roll onto the hip that is closest to the camera. This is slimming to the seat, thigh and upper parts of the leg, because it hides a good portion of these areas behind the subject.

Anytime the legs are going to be showing and not covered with pants, have the subject wear the tallest heels she owns. There is a reason why women who want to have the greatest impact when wearing a dress wear very high heels. When the heel is pushed up, it flexes the calf and thigh muscle, making the legs appear longer and firmer. If the woman is going barefoot, have her push up her heels just as high heeled shoes would do.

Another way to make the legs appear longer is to use the distortion of a wide-angle lens to lengthen the legs. When you use a wide-angle lens, an object that is close to the lens appears larger (or having more distance between the foreground and the middle or background). By having a young lady extend her feet and legs towards the camera, the legs

then appear to be lengthened. On the Bronica 645 camera we use a 50mm lens (equivalent to a 30mm lens on a 35mm format camera), usually at f/16 to ensure that everything from the feet to the face is in focus.

This list does not by any means include all the flaws that you will encounter when working with clients each day in a studio situation, but these are some of the worst problems you will encounter. As you start practicing corrective lighting and posing you will find it gets progressively easier and faster to find and fix your client's problems.

Using wide-angle distortion to your advantage can give your subject the appearance of longer legs.

Clothing Selection 6

Most photographers have gotten to a point where they coordinate the basic color of a client's clothing to that of the background, set or outdoor scene. Darker tones of clothing are paired with darker backgrounds. Lighter tones of clothing are paired with a lighter background. This makes the viewer's eye focus on the person and not what the person is wearing. It also gives you the ability to hide body size, because you don't create an exact outline of the client's body as you would with a white dress on a black background. To create a portrait that has a sense of style, however, you not only need to coordinate the color of the clothing to the scene, but also the style of the clothing, which must reflect a similar feeling as that reflected in the scene. Although correcting flaws is important to the client, the portrait must also visually "make sense." This can only happen when each aspect of the portrait complements the other.

"... have them bring in everything for you to look at. I am not kidding."

■ Clothing Guidelines

Probably the best advice I can give you in regard to your clients' clothing is to have them bring in everything for you to look at. I am not kidding. We tell our seniors to bring in everything, and they do. The average girl brings in 10-25 changes, the average guy brings 5-12. By doing this, you always have other choices when a favorite outfit is a bad choice for a particular subject.

Long Sleeves. In our consultation video, we explain how important it is to bring in the proper styles of clothing. We suggest long sleeves for all portraits that are to be taken

Pairing dark clothes with darker settings and light clothes with lighter settings helps keep the emphasis on the person. It also makes it easier to disguise common figure problems by letting the body blend in with the background.

from the waist up. Large arms are much less noticeable in a full length pose, so short sleeves are less of a problem in these portraits.

Black Clothing. We also suggest that anyone who worries about weight should bring in a variety of darker colors of clothing and several choices that are black. Black clothing is amazing. It will take ten to thirty pounds off of anyone who wears it, provided you use common sense and pair it with a black or very dark tone background. If you are photographing a family and Dad has a "beer belly," ask him to wear a black sweater. Unless his stomach is huge, it will appear flat in the final portrait. If Mom has larger hips, put her in a black skirt or dress and she will appear noticeably thinner.

High Heels. Anytime a woman will be in a dress, we ask her to bring in the highest heel she owns to wear with it. If she doesn't have any 3-inch heels, she can borrow them from a friend. If the legs are showing, panty hose should be worn unless the subject has very tan legs with great muscle tone. The nylons will not only make the legs look better by darkening them, but will make them appear firmer and disguise signs of cellulite.

■ **Common Problems**

With clothing, the easy way to know what to do is to know what not to do. If you think in terms of all the problems that clothing can create for your clients and then help them avoid these problems, you will learn how to use your clients' clothing to make them look their best. Here are some common problems that should be avoided.

Too Tight or Too Loose Clothing. We warn clients against wearing jeans or pants that are too tight around the waist. Unless the subject is in great shape, he or she will have a roll where the tight jeans cut into the waist. Tight clothing

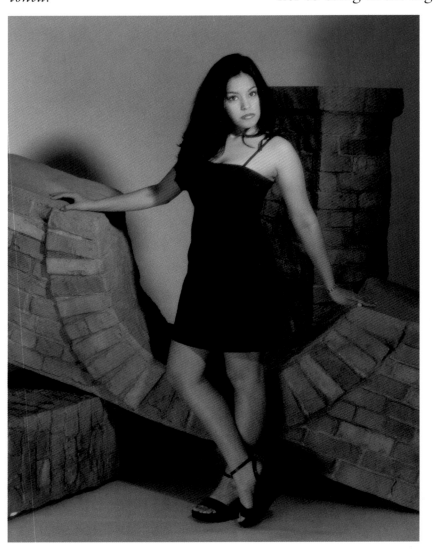

Black (and other dark colors) is flattering on everyone. Anytime a woman will be in a dress, wearing high heels will make her legs look more slim and toned.

also effects the subject's ability to pose comfortably. I have had some seniors turn beet red because of tight pants as they try to get into a pose. For this reason, we ask all of our clients to bring in a comfortable pair of shorts in summer or sweatpants in winter, to make it as easy as possible to get into the poses—at least those that won't show below the waist.

If women have a frequent problem with tight jeans, guys (especially young guys) have the baggies. This cool-looking (so they think) style has the crotch that hangs down to their knees, while at the same time revealing undergarments and butt-cleavage to the world. Just try to pose a client in a seated position when there are three yards of material stretched out between his legs. Try to have him put his hands in pants pockets which are hanging so low he can't even reach them.

In general, clothing that is loose-fitting on a person who is thin and/or athletic will add weight to the person in the portrait, especially if it is loose at the waist or hips. Tight clothing will add weight to those people who are heavier. With tight clothing on a heavy person you can see tummy bulges, cellulite, lines from waistbands and every other flaw that weight brings to the human body.

Wrong Undergarments. Many women also forget to bring in the proper undergarments. They bring light clothing, but only have a black bra and underwear. They bring in a top with no straps or spaghetti straps and they don't have a strapless bra. In this case, they either have to have the straps showing or not wear a bra, which for most women isn't a good idea.

Guys are no better. I can't count the number of times I have had a guy show up with a dark suit and nothing but white socks. Some men (okay, most men) tend to be more sloppy than women, which means that the clothing they bring often looks like it has been stored in a big ball at the bottom of their closet for the last three months. Many show up with clothing that used to fit ten years ago when it was actually in fashion.

"Many show up with clothing that used to fit ten years ago..."

Correcting Flaws with the Scene 7

"... elements in the scene can also be used to cover up a problem."

The scene or setting can often be one of the most effective tools you have for correcting the flaws that clients have. As we have shown, by making the background appear black in a problem area like large hips or a balding head, you can make the problem much less noticeable. Using the background in this manner works well in low key portraits, but when you start working with high key settings (even with the client in light clothing), the problem area is still obvious. But, just as with poses that use the knee, arm or leg to disguise a problem, elements in the scene can also be used to cover up a problem.

■ Using the Foreground

Most scenes give you many ways to hide flaws by using an often overlooked part of the set-up—the foreground. Many photographers, especially those who are more traditional in their tastes, think of a portrait in terms of the subject and background. The foreground is the one missing element in almost every portrait that is taken in the studio by most photographers.

Making use of the foreground not only gives you the ability to hide a client's flaws but, from an artistic standpoint, it gives you a greater ability to create the illusion of depth in your portraits. Creating depth (or the illusion of a third dimension on a two dimensional piece of photographic paper) is our most basic task as professional photographers. By using an element in the foreground, the subject in critical focus, and then a background that recedes farther

and farther from the subject, you have a built-in sense of depth.

When it comes to correcting a client's flaws, it is amazing how even a simple foreground element like a plant or a few columns can soften or hide a large hip, tummy bulge, large upper arm or hairy forearm. Whether you have something as simple as a client sitting backwards in a chair, or an entire set arranged to hide problem areas, it is a very effective way to give clients a version of reality they can live with.

Since many photographers don't use foreground elements at all, learning how to coordinate foreground elements with the background can be challenging. We recently purchased an EPS Scene Machine, which is a popular front-projection system. The basic idea behind front projection is that by combining a beam splitter, a highly reflective background screen and a slide projection system, you can make any slide (from 35mm to 2-1/4 square) your background.

Yet, as I looked at the work of photographers who used the Scene Machine, I saw that almost none of them used any foreground. This system has so much potential. To reduce it down to providing a flat projected background surface without any depth is a waste. If you are going to do that, you can save the money and get some scenic lithoprints.

(Opposite and below) Using scene elements is one of the best tools you can use to conceal flaws.

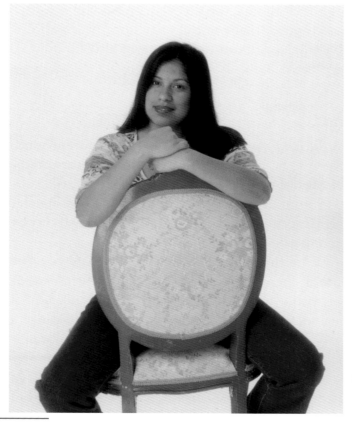

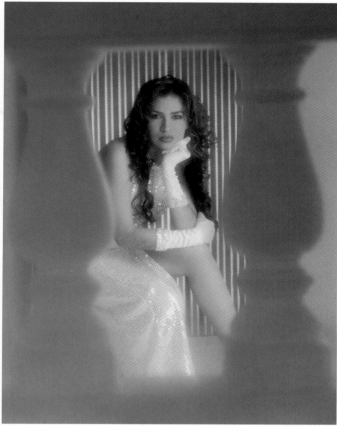

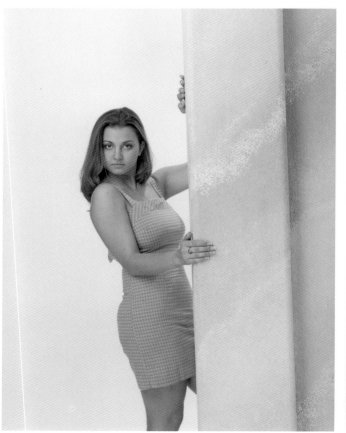

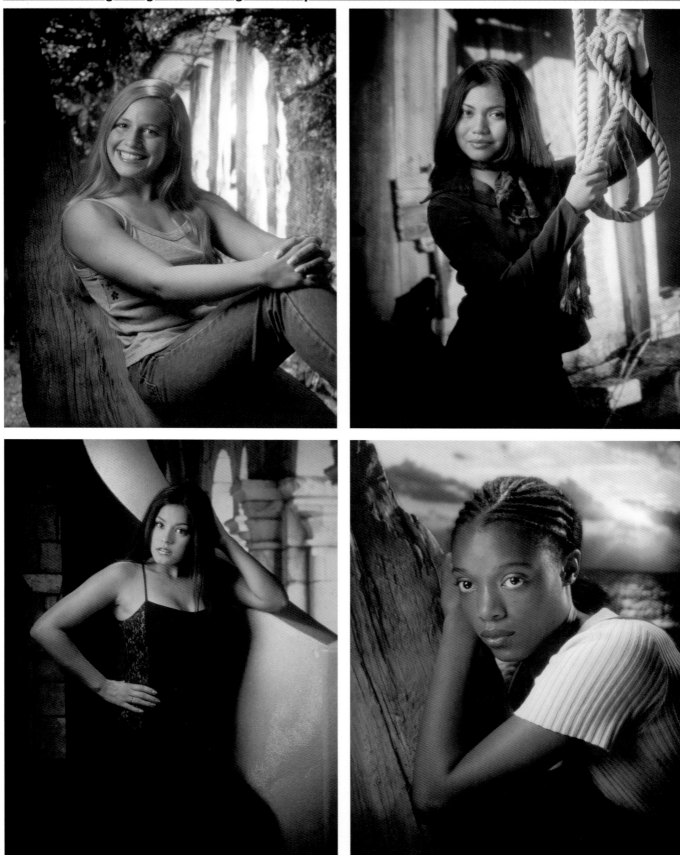

(Opposite and above) When using a two-dimensional background of any kind, adding a foreground element will add depth.

Adding a foreground element can be as easy as a trip to the local home improvement store for a set of stairs, a French door, a ladder, or any number of other potential set elements. Best of all, these items can be very economical.

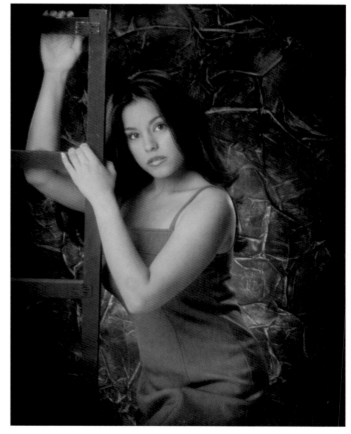

Whether you are using a painted background, seamless paper or even a projection screen, it is a flat two dimensional surface. Painted backgrounds have textures to make them appear to have depth. You can cast a shadow on seamless paper by passing light through a plant or tree. The projection screen gives the illusion of depth, but its depth is limited by the slide that you are using. Whatever type of background you use, you can create more of a feeling of depth by using multiple elements in the foreground at different distances between the camera and subject. You can also add more elements between the subject and the background.

The hardest part of using foreground elements is coordinating the style, look and color to the other parts of the scene. A plant or tree is often used in the foreground because it is easy. It goes with just about everything and it doesn't take any time to prepare. Chairs are also a popular choice for the foreground element. Either one can be effective.

We have found many background and foreground elements at the local home store. I purchased a French door on the clearance aisle for $10, and this was a nice addition. We have also purchased ladders, steel grates, tin roofing material and many other interesting foreground and background items at this type of store. You are only limited by your imagination and your time to shop around. When I first opened my studio, like most new photographers I had all kinds of time, but very little money to purchase pre-made sets. Now, with over 3000 seniors to photograph each year, my writing and my family, I have much more money than I do time to look for background items.

I use many backgrounds and set components from Scenic Designs. They manufacture foam set pieces like the brick and stone arch set. Units like these are two-sided to increase their versatility. My favorite products from Scenic Designs are the rubber walls. These walls come in a variety of textures and look completely real. For our stone and brick wall, we made an "L" shaped frame out of 2x4-inch lumber. We stapled the "stone" rubber wall to one side of the frame and the "brick" rubber wall to other. To make the wall easy to move, we put casters on the frame. We have had quite a few seniors' moms lean on that wall thinking it is real and almost fall over when it started to roll away.

Another popular pre-made set is the spiral staircase from Off the Wall. Although these sets seem large and bulky, they

"We have found many background and foreground elements at the local home store."

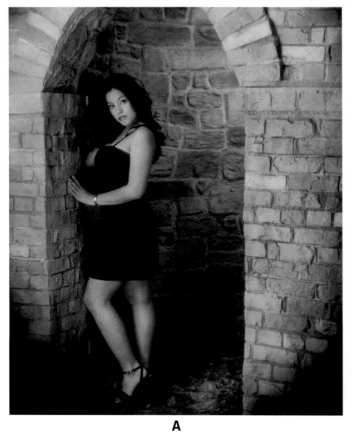

A

B

C

Foam set elements like this brick archway (A and B) look very real and are easy to work with. This spiral staircase (C) may look bulky, but it comes together from several smaller pieces and is very easy to move around.

all come together from several smaller pieces that store away quite easily. The young lady who moves my sets for me is 5'1" and petite. If she can move them, anyone can.

As you start working with sets, whether you purchase them or create your own, you need to look for unique ways to use the set components. The average photographer sees an arch at a trade show. He buys it, and gets it into his studio and it remains a single arch for all time. Yet, in addition to being an arch, it is also three individual pieces that can be combined with other set components to create multiple uses for a single set component. Throughout the illustrations in this book, you have seen portions of the arch and spiral stairs used in different ways to achieve many uses for two individual sets. This is getting the most out of your time and money—and giving you more opportunities to improve your photographs and hide your client's flaws.

"... look for unique ways to use the set components."

8 | Outdoor Portraits

As photographers have long known, a session shot on location (or partially on location) will have a higher sales average than a session done in the studio alone. Yet, many photographers fear the great outdoors like the plague—and for good reasons.

◼ Problems with Outdoor Shoots

While outdoor sessions can boost profits, working outside gives you little control over your lighting—at least the kind of control needed for corrective lighting.

We are all taught that to achieve the best possible portraits outdoors we have to get up at the crack of dawn, or stay out until it is almost dark. We have all been told that the ideal lighting exists for an 1.5 hour window after sunrise and your next opportunity starts at an 1.5 hours before sunset. Realistically, this give you about two 1.5-hour windows of opportunity per day.

To add to the these problems, you have to schedule your "time management" clients of today in this limited amount of time. These are the same clients that tell you that if they can't do their session at three in the afternoon on a Sunday, they just won't have you do their portraits.

Now let's talk about money. Unless your studio is located on the beach, next door to a park or in the mountains, you are probably going to have to travel to and from the location your client has selected to use. Most photographers, to compensate for this travel, charge a higher sitting fee. Charging the higher fee means fewer clients will take

"... many photographers fear the great outdoors like the plague..."

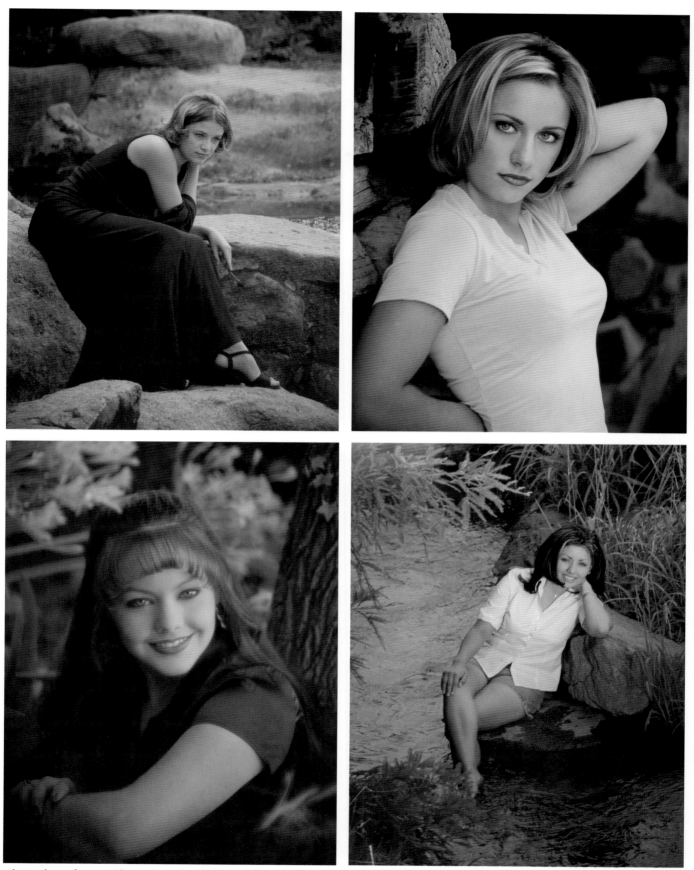

A session shot on location (or in combination with studio photography) will have a higher sales average than a session shot in the studio alone.

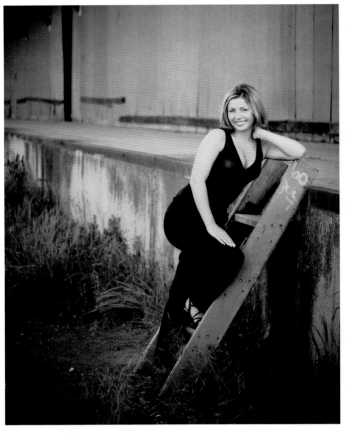

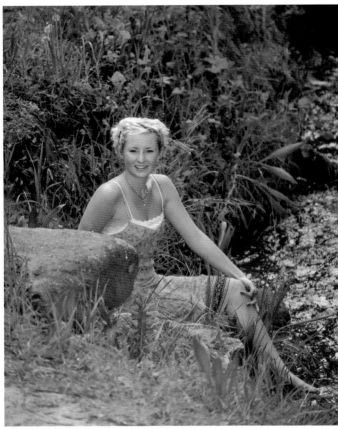

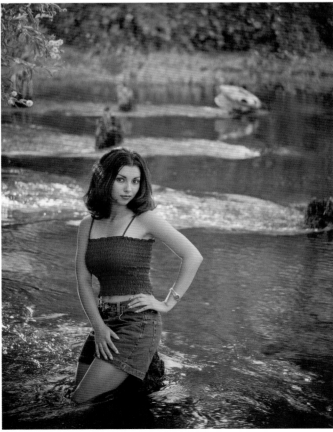

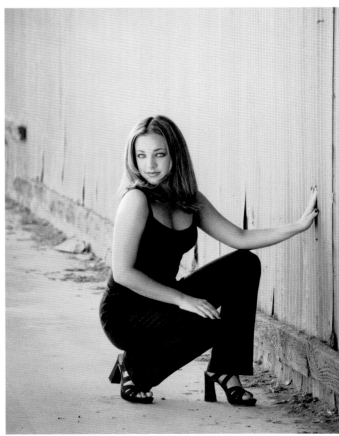

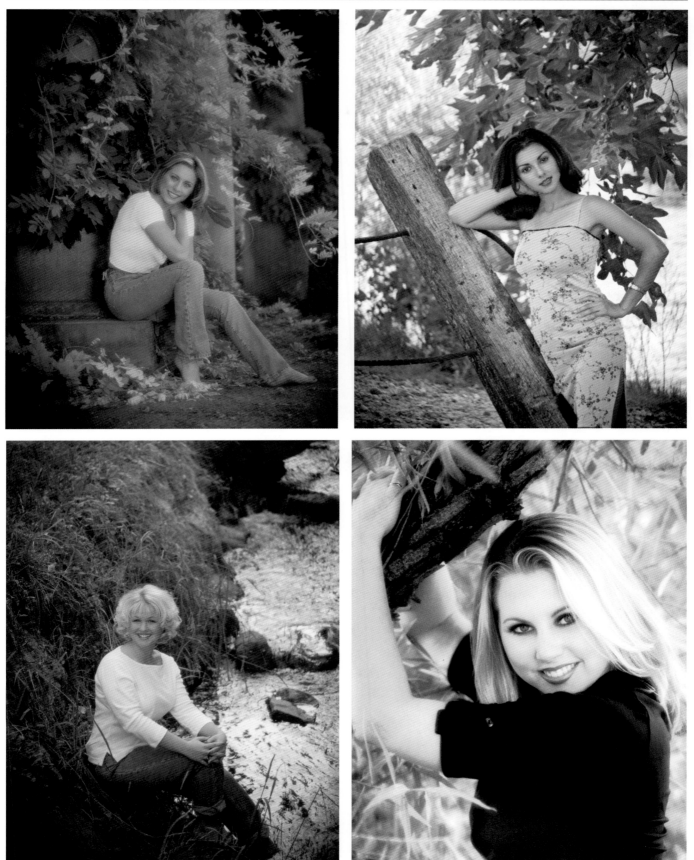

advantage of the sessions at outdoor locations, so you lose the higher profit from these sessions.

To overcome the problems with sessions on location, we decided to do two things. First, we needed to learn how to work with the natural light as it changes throughout the day. Second, we selected a certain number of outdoor locations at which to offer sessions, and then began scheduling blocks of appointments at these locations to cover the cost of travel. This meant we could offer these session to the clients with no additional charge.

Learning how to work with natural light at different times of the day took some getting used to. Like most photographers, I had used flash for outdoor group portraits at weddings, but the flash all but destroyed the feeling of the soft, warm, outdoor light that exists naturally. Therefore, flash was not an option I preferred.

Booking blocks of appointments at a few selected sites lets us offer location portraits at no extra charge to the client.

The other option was to manipulate the existing light with a combination of reflectors and black panels, what Leon Kennamar used to call "subtractive lighting." With the advances in the quality of higher speed portrait films and the selection of reflectors and panels offered by manufacturers, this type of control over outdoor lighting has come a long way.

Now, as we venture into the great outdoors, we use the light that exists and modify it to fit the situation. Since we specialize in seniors, the techniques we use are designed for photographing a single person, but the principles will work on a couple or even a small group.

Working with midday light, you will find two different lighting situations. The first scene (the ideal one) occurs when you get lucky and find in one location an obstruction that blocks the light from directly overhead (under a tree with branches overhead, or on a porch with the roof overhead), and a second obstruction on one side or the other at ground level. This creates a shadow area and a large, directional light source to act as the main light.

> "... we use the light that exists and modify it to fit the situation."

Lens Selection

Whether we are working inside or out, almost all the portraits are taken with a 150mm lens. The only time I change lenses is to use a wide-angle for a change of perspective. I never use a normal 80mm lens—ever. A normal lens gives you just that, a normal view of the world. It isn't distorted, it doesn't compact the depth of field, it looks normal. It looks the same as the images your client takes with his or her own normal lens.

Many photographers only use an 80mm lens (for 645 format) when they are doing full lengths, to cut down on the distance needed to use a 150mm. When photographers do this, what do they end up with? A normal looking, run of the mill picture that the client could have recorded with their 35mm camera.

Full lengths, more than any other type of pose, need the reduced depth of field that a telephoto has. It draws the viewer's eye to the subject. Anything outside the area from ten inches in front of the subject to a foot behind the subject appears soft, adding impact to the subject.

In the second type of scene, one or more of the key elements needed to create the ideal scene is missing. In this case, you must identify what is needed to create portrait-quality lighting, and use black panels and reflectors to fix the problems. For more on outdoor portrait photography, refer to one of the best books ever written on the subject (if, as the author, I do say so myself), called *Outdoor and Location Portrait Photography*, from Amherst Media.

■ Use of Shadow

When it comes to corrective lighting for outdoor portraits, the use of shadow can soften the flaws that your clients have. Shadow is also the missing element from most photographer's outdoor portraits. Most outdoor portraits I see have a main light source that is too large and wraps light around the entire face. This type of light makes the face look wide and without structure. By placing a black panel on one side of the subject, a shadow is created and the face appears thinner. This also creates a shadow side of the portrait to turn the body into to hide flaws.

■ Eyes and Direction of Light

The eyes are the best indicator of light direction and the modifications that need to be made. What you are looking for is one large, well-defined catch light in the upper half of each eye. This catch light should be to one side or the other of the pupil of the eye, as well as positioned in the color portion of the eye.

As you look at your subject's eyes, if the catch lights are too large and extend from one side of the pupil to the other, or if there are two distinct catch lights on each side of the pupil, the light has direction, but needs to be modified to create a shadow. One very large catch light means the source of light is too large. You need to turn your subject away from the source of natural light (probably the open sky) until the catch lights in the eyes are in the proper position.

You can try to do the same thing when the light produces two distinct catch lights. If turning the subject doesn't eliminate the second catch light or reduce the size of the catch light enough, you can bring in a black panel. You simply place the black panel in front and to the side of the subject to eliminate the second catch light or reduce the size of the natural main light source.

"One very large catch light means the source of light is too large."

To create soft natural light outdoors, use a mirror to reflect light through a translucent panel placed in the main-light position.

■ Using Mirrors and Translucent Panels

If you don't have the perfect light, create it. Outdoors, the closest light that you can produce to the light from soft boxes in the studio is created using mirrors and translucent panels. Use a large mirror for the main light source. Position it to reflect direct sunlight through the translucent panel in the main light position. I also like to have a light coming from underneath the subject (like the mylar from the drafting table or light on floor of the studio), so we also place a second smaller mirror to pass direct sunlight through the translucent in a lower position. It's softer than a reflector, and completely controllable.

■ Positioning a Reflector

There are two times when you will need to use a reflector. The first is to add, but not overpower, the natural main light. The second use is to produce catch lights in the eyes—turning the reflector into the main light. In either case, you need to get used to working with the reflector to produce the type of light you need.

Reflecting direct sunlight onto a subject's face with a silver or gold reflector provides a less-than-photographic qual-

ity light, not to mention being inhumane. To make this raw quantity of light usable for the main light of a portrait, you must feather the light, just like you would in the studio. To feather the light from a reflector, angle the direct beam of light so it is near but not on the subject. As you get this direct beam of light closer to the subject you will see the amount of light on the subject increase.

Feathering raw light can make it usable for the main light of a portrait. As you can see, the beam of reflected light is on the wall just above her head.

■ **Using the Outdoor Scene Effectively**

Working at an outdoor location gives you more opportunity than in your studio to hide your clients' flaws. Although you have less precise control over the lighting, you have many elements to use in the foreground and background to soften the outline of the subject's body.

Hiding White Socks and Feet. A client comes out and despite everything you have told him, he has a white pair of socks gleaming out of a dark pant leg. The solutions are many. You can look for tall grass to pose him in, so you won't see the white socks. You can angle the shot, so that a tree branch or other foliage in the foreground covers the area of the white socks. The same ideas can be used to hide

a girl's feet if she wants to go barefoot, but either hasn't painted her nails or has painted them a bright color.

Arms. The identical technique can be used when you have a young lady with large arms who hasn't listened to your instructions and has brought out nothing but sleeveless tops. Look for foliage in the foreground that is at the proper height and comes into the frame at the proper angle to cover a portion of her large arm.

Many times a scene is perfect, but there is no foliage or other elements in the foreground to soften or hide a problem area. At this point, you'll need to go to a tree and do a little "constructive pruning." Snatch a branch off of a nearby tree and add it into the frame of the portrait where you need it to hide the flaw.

■ Selecting a Scene

To work effectively outdoors, many photographers need to re-learn how to locate a scene. To find the perfect scene, you must first determine the most important quality of a scene for taking portraits. Is it a location with perfect light? Most photographers would think so, but they would be wrong. I can create beautiful light, so to select a scene based only on the quality of light would be a mistake.

What about the quality of shadow? Is there an obstruction above the subject to block the light from overhead, avoiding "raccoon eyes," and an obstruction to one side of the subject to create a shadow area in the portrait? This is important to thin the face and body, but I can create shadow wherever I want it so, again, to make this the determining factor in scene selection would be a mistake.

What about the appearance of the scene? When you are working in the middle of the day, usable backgrounds or scenes are in short supply, but no matter how perfect the scene is, no matter how perfect the light or shadow, if you have a girl who is overweight and you don't do anything to make her look thinner, all of your work is for nothing, because in all likelihood she will not order.

The first priority, when you are looking for a spot and using corrective techniques, is to determine what that scene is going to provide you with to hide your clients' flaws. Once this is determined, you can work at sorting everything else out. If the background is in sunlight, you'll need to add light from a reflector, or mirrored light can be passed through a translucent panel to balance the lighting on the subject with

"... determine the most important quality of a scene for taking portraits."

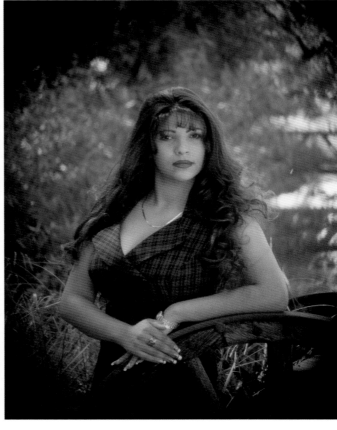

When photographing portraits outdoors, look for obstructions you can use to hide problems and make your clients look their best.

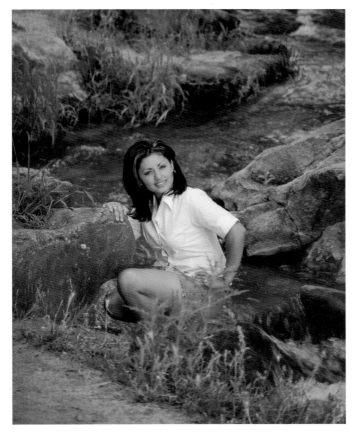

that of the background. If you don't have enough shadow, bring in black panels to create shade.

If this approach seems different to you, or you think this sounds like too much work, just think of it in terms of working in the studio. If you walked into a studio and the only main light source you had to work with was a large window

that faced the north, what would you say? Most photographers would say, "Get me some lights, some equipment! I am not a 17th century painter, I am a 21st century photographer!" Although window light is beautiful, it can only produce one look.

Once you take this approach to outdoor portraits, you aren't taking just what mother nature is willing to give you. Instead, you are creating beautiful portraits outdoors, just like you would in the studio— taking the best that is given to you and improving it.

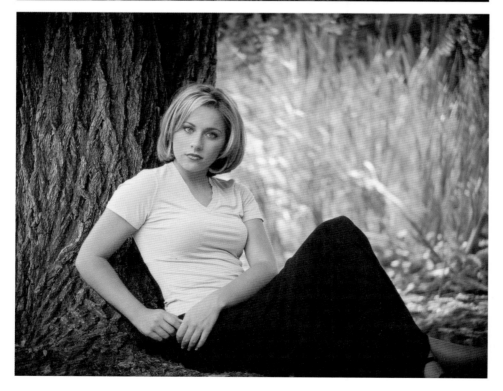

Many times a client will ask for a particular outdoor spot that has nothing available to help hide problems. Even though this young lady is thin, the waistband created a problem that we had to correct in posing. In this case, simply moving her left arm concealed the problem.

117

9 | Conclusions

If you have taken beautiful sunset photographs on the beaches in Cancun, or great landscapes in Yosemite, or beautiful portraits of beautiful people, congratulations. You have mastered the basics of photography. With a basic understanding of a camera's operation and how to use a light meter, most anyone can take great sunset pictures on some of the most beautiful beaches in the world. What hobbyist couldn't wander around Yosemite without taking some great landscapes? After all, it is one of the world's most beautiful national parks. What photography student couldn't take a beautiful portrait of a beautiful person? Reality is exactly what the camera is designed to record.

Many photographers base the value of their skill or their own level of expertise on their best photographs of their most beautiful clients. To be a professional and enjoy the profit from every session (not just the sessions of beautiful people) you need to look at your least photogenic clients and see how you made them look. Do you give them a version of reality that they can live with, or is your mind working desperately to save your ego, by telling yourself, "What do you expect, she or he was too overweight, too short, too homely, etc.?"

When I was a young professional and trying to define the direction of my business, I really tried to make each client look his or her best. Quite frankly, in those days I couldn't afford to lose any clients. On one occasion, I had photographed a young senior girl who was probably 60 to 80 pounds overweight. I used a very contrasty light to have a

"... look at your least photogenic clients and see how you made them look."

very dark shadow, thinning the face. I used poses that hid her very large double chin from the perspective of the camera. I picked out her clothing, all of which was very dark, and used her long hair to soften the size of her shoulders and arms. At that point in time in the studio, I was not only the photographer, but also the person who delivered the proofs to the client. When this girl and her mother came in to the studio and started to look at her proofs, the mother started to cry. The mother said, "I have always told my daughter that, despite her weight, she is a beautiful young lady and these portraits show the beautiful young lady she is." The mother gave me a hug and thanked me. This is a session I will never forget, because for the first time I understood how much a professional portrait means to our clients.

I think this is the flawed part of photographic judging. For every print submitted, there should be a before and an after. In this way, the judges could see the person whom the photographer was photographing and how good the photographer made that person look in the final portrait. This would be a true test of the photographer's talent and expertise—not just a testament to the fact that he or she has mastered basic photography sufficiently to make a beautiful person appear beautiful in the portrait.

If I could leave you with one message, it would be to care about your clients—all your clients. Put the same effort into a session with a person who has obvious flaws as you do into a session with the perfect people you invite to come in for test sessions. Base your measurement of your growth on how good you can make each client look, not on your best photographs of your most beautiful clients.

"... care about your clients—all your clients."

Index

Wedding Photojournalism

Andy Marcus

Learn to create dramatic unposed wedding portraits. Working through the wedding from start to finish, you'll learn where to be, what to look for, and how to capture it. $29.95 list, 8½x11, 128p, 60 b&w photos, order no. 1656.

Professional Secrets of Wedding Photography
2nd Ed.

Douglas Allen Box

Top-quality portraits are analyzed to teach you the art of professional wedding portraiture. Lighting diagrams, posing information, and technical specs are included for every image. $29.95 list, 8½x11, 128p, 80 color photos, order no. 1658.

Photographer's Guide to Shooting Model & Actor Portfolios

C J Elfont, Edna Elfont, and Alan Lowy

Create outstanding images for actors and models looking for work in fashion, theater, television, or the big screen. Includes the business and photo techniques you need! $29.95 list, 8½x11, 128p, 100 b&w and color photos, order no. 1659.

Photo Retouching with Adobe® Photoshop®
2nd Ed.

Gwen Lute

Teaches every phase of the process, from scanning to final output. Learn to restore damaged photos, correct imperfections, create realistic composite images, and correct for dazzling color. $29.95 list, 8½x11, 120p, 100 color images, order no. 1660.

Creative Lighting Techniques for Studio Photographers, *2nd Ed.*

Dave Montizambert

Whether you are shooting portraits, cars, tabletop, or any other subject, Dave Montizambert teaches you the skills you need to take complete control of your lighting. $29.95 list, 8½x11, 120p, 80 color photos, order no. 1666.

Marketing and Selling Black & White Portrait Photography

Helen T. Boursier

Complete manual for adding b&w portraits to the products you offer clients (or offering exclusively b&w). Learn to attract clients and deliver portraits that will keep them coming back. $29.95 list, 8½x11, 128p, 80 b&w photos, order no. 1677.

Composition Techniques from a Master Photographer

Ernst Wildi

Composition can make the difference between dull and dazzling. Master photographer Ernst Wildi teaches you his techniques for evaluating subjects and composing powerful images in this beautiful color book. $29.95 list, 8½x11, 128p, 100 color photos, order no. 1685.

Posing and Lighting Techniques for Studio Photographers

J. J. Allen

Master the skills you need to create beautiful lighting for portraits. Posing techniques for flattering, classic images help turn every portrait into a work of art. $29.95 list, 8½x11, 120p, 125 color photos, order no. 1697.

Watercolor Portrait Photography
THE ART OF POLAROID SX-70 MANIPULATION

Helen T. Boursier

Create one-of-a-kind images with this surprisingly easy artistic technique. $29.95 list, 8½x11, 128p, 200 color photos, order no. 1698.

Make-up Techniques for Photography

Cliff Hollenbeck

Step-by-step text and illustrations teach you the art of photographic make-up. Learn to make every portrait subject look his or her best with great styling techniques for black & white or color photography. $29.95 list, 8½x11, 120p, 80 color photos, order no. 1704.

Professional Secrets of Natural Light Portrait Photography

Douglas Allen Box

Use natural light to create hassle-free portraiture. Beautifully illustrated with detailed instructions on equipment, lighting, and posing. $29.95 list, 8½x11, 128p, 80 color photos, order no. 1706.

Portrait Photographer's Handbook

Bill Hurter

Bill Hurter has compiled a step-by-step guide to portraiture that easily leads the reader through all phases of portrait photography. This book will be an asset to experienced photographers and beginners alike. $29.95 list, 8½x11, 128p, 100 color photos, order no. 1708.

Professional Marketing & Selling Techniques for Wedding Photographers

Jeff Hawkins and Kathleen Hawkins

Learn the business of wedding photography. Includes consultations, direct mail, advertising, internet marketing, and much more. $29.95 list, 8½x11, 128p, 80 color photos, order no. 1712.

Advanced Infrared Photography Handbook

Laurie White Hayball

Building on the techniques covered in her *Infrared Photography Handbook*, Laurie White Hayball presents advanced techniques for harnessing the beauty of infrared light on film. $29.95 list, 8½x11, 128p, 100 b&w photos, order no. 1715.

Zone System

Brian Lav

Learn to create perfectly exposed black & white negatives and top-quality prints. With this step-by-step guide, anyone can learn the Zone System and gain complete control of their black & white images! $29.95 list, 8½x11, 128p, 70 b&w photos, order no. 1720.

Selecting and Using Classic Cameras

Michael Levy

Discover the charms and challenges of using classic cameras. Folders, TLRs, SLRs, Polaroids, rangefinders, spy cameras, and more are included in this gem for classic camera lovers. $17.95 list, 6x9, 196p, 90 b&w photos, order no. 1719.

Traditional Photographic Effects with Adobe® Photoshop®, 2nd Ed.

Michelle Perkins and Paul Grant

Use Photoshop to enhance your photos with handcoloring, vignettes, soft focus, and much more. Every technique contains step-by-step instructions for easy learning. $29.95 list, 8½x11, 128p, 150 color images, order no. 1721.

Master Posing Guide for Portrait Photographers

J. D. Wacker

Learn the techniques you need to pose single portrait subjects, couples, and groups for studio or location portraits. Includes techniques for photographing weddings, teams, children, special events and much more. $29.95 list, 8½x11, 128p, 80 photos, order no. 1722.

Photographic Lenses

PHOTOGRAPHER'S GUIDE TO CHARACTERISTICS, QUALITY, USE AND DESIGN

Ernst Wildi

Gain a complete understanding of the lenses through which all photographs are made—both on film and in digital photography. $29.95 list, 8½x11, 128p, 70 color photos, order no. 1723.

The Art of Color Infrared Photography

Steven H. Begleiter

Color infrared photography will open the doors to a new and exciting photographic world. This book shows readers how to previsualize the scene and get the results they want. $29.95 list, 8½x11, 128p, 80 color photos, order no. 1728.

The Art of Photographing Water

Cub Kahn

Learn to capture the interplay of light and water with this beautiful, compelling, and comprehensive book. Packed with practical information you can use right away! $29.95 list, 8½x11, 128p, 70 color photos, order no. 1724.

High Impact Portrait Photography

Lori Brystan

Learn how to create the high-end, fashion-inspired portraits your clients will love. Features posing, alternative processing, and much more. $29.95 list, 8½x11, 128p, 60 color photos, order no. 1725.

Legal Handbook for Photographers

Bert P. Krages, Esq.

This book offers examples that illustrate the *who, what, when, where* and *why* of problematic subject matter, putting photographers at ease to shoot without fear of liability. $19.95 list, 8½x11, 128p, 40 b&w photos, order no. 1726.

Digital Imaging for the Underwater Photographer

Jack and Sue Drafahl

This book will teach readers how to improve their underwater images with digital imaging techniques. This book covers all the bases—from color balancing your monitor, to scanning, to output and storage. $39.95 list, 6x9, 224p, 80 color photos, order no. 1727.

The Art of Bridal Portrait Photography

Marty Seefer

Learn to give every client your best and create timeless images that are sure to become family heirlooms. Seefer takes readers through every step of the bridal shoot, ensuring flawless results. $29.95 list, 8½x11, 128p, 70 color photos, order no. 1730.

Photographer's Filter Handbook

Stan Sholik and Ron Eggers

Take control of your photography with the tips offered in this book! This comprehensive volume teaches readers how to color-balance images, correct contrast problems, create special effects, and more. $29.95 list, 8½x11, 128p, 100 color photos, order no. 1731.

Beginner's Guide to Adobe® Photoshop®, 2nd Ed.

Michelle Perkins

Learn to effectively make your images look their best, create original artwork, or add unique effects to any image. Topics are presented in short, easy-to-digest sections that will boost confidence and ensure outstanding images. $29.95 list, 8½x11, 128p, 300 color images, order no. 1732.

Photographer's Guide to Slide Duplication and Enhancement

Ben Duben

Whether you're looking to backup a slide or add impact to it, the advice offered in this book will make the process painless. $29.95 list, 8½x11, 112p, 130 color photos, order no. 1733.

Professional Techniques for Digital Wedding Photography, 2nd Ed.

Jeff Hawkins and Kathleen Hawkins

From selecting equipment, to marketing, to building a digital workflow, this book teaches how to make digital work for you. $29.95 list, 8½x11, 128p, 85 color images, order no. 1735.

Lighting Techniques for High Key Portrait Photography

Norman Phillips

Learn to meet the challenges of high key portrait photography and produce images your clients will adore. $29.95 list, 8½x11, 128p, 100 color photos, order no. 1736.

Photographer's Lighting Handbook

Lou Jacobs Jr.

Think you need a room full of expensive lighting equipment to get great shots? With a few simple techniques and basic equipment, you can produce the images you desire. $29.95 list, 8½x11, 128p, 130 color photos, order no. 1737.

Beginner's Guide to Digital Imaging

Rob Sheppard

Learn how to select and use digital technologies that will lend excitement and provide increased control over your images—whether you prefer digital capture or film photography. $29.95 list, 8½x11, 128p, 80 color photos, order no. 1738.

Professional Digital Photography

Dave Montizambert

From monitor calibration, to color balancing, to creating advanced artistic effects, this book provides those skilled in basic digital imaging with the techniques they need to take their photography to the next level. $29.95 list, 8½x11, 128p, 120 color photos, order no. 1739.

Group Portrait Photographer's Handbook

Bill Hurter

With images by top photographers, this book offers timeless techniques for composing, lighting, and posing group portraits. $29.95 list, 8½x11, 128p, 120 color photos, order no. 1740.

LIGHTING AND EXPOSURE TECHNIQUES FOR Outdoor and Location Portrait Photography

J. J. Allen

Meet the challenges of changing light and complex settings with techniques that help you achieve great images every time. $29.95 list, 8½x11, 128p, 150 color photos, order no. 1741.

Toning Techniques for Photographic Prints

Richard Newman

Whether you want to age an image, provide a shock of color, or lend archival stability to your black & white prints, the step-by-step instructions in this book will help you realize your creative vision. $29.95 list, 8½x11, 128p, 150 color and b&w photos, order no. 1742.

The Art and Business of High School Senior Portrait Photography

Ellie Vayo

Learn the techniques that have made Ellie Vayo's studio one of the most profitable senior portrait businesses in the US. $29.95 list, 8½x11, 128p, 100 color photos, order no. 1743.

The Best of Nature Photography

Jenni Bidner and Meleda Wegner

Ever wondered how legendary nature photographers like Jim Zuckerman and John Sexton create their images? Follow in their footsteps as top photographers capture the beauty and drama of nature on film. $29.95 list, 8½x11, 128p, 150 color photos, order no. 1744.

Beginner's Guide to Nature Photography

Cub Kahn

Whether you prefer a walk through a neighborhood park or a hike through the wilderness, the beauty of nature is ever present. Learn to create images that capture the scene as you remember it with the simple techniques found in this book. $14.95 list, 6x9, 96p, 70 color photos, order no. 1745.

Photo Salvage with Adobe® Photoshop®

Jack and Sue Drafahl

This book teaches you to digitally restore faded images and poor exposures. Also covered are techniques for fixing color balance problems and processing errors, eliminating scratches, and much more. $29.95 list, 8½x11, 128p, 200 color photos, order no. 1751.

The Art of Black & White Portrait Photography

Oscar Lozoya

Learn how Master Photographer Oscar Lozoya uses unique sets and engaging poses to create black & white portraits that are infused with drama. Includes lighting strategies, special shooting techniques and more. $29.95 list, 8½x11, 128p, 100 duotone photos, order no. 1746.

The Best of Wedding Photography

Bill Hurter

Learn how the top wedding photographers in the industry transform special moments into lasting romantic treasures with the posing, lighting, album design, and customer service pointers found in this book. $29.95 list, 8½x11, 128p, 150 color photos, order no. 1747.

Photographing Children with Special Needs

Karen Dórame

This book explains the symptoms of spina bifida, autism, cerebral palsy, and more, teaching photographers how to safely and effectively capture the unique personalities of these children. $29.95 list, 8½x11, 128p, 100 color photos, order no. 1749.

The Best of Children's Portrait Photography

Bill Hurter

Rangefinder editor Bill Hurter draws upon the experience and work of top professional photographers, uncovering the creative and technical skills they use to create their magical portraits. $29.95 list, 8½x11, 128p, 150 color photos, order no. 1752.

Wedding Photography with Adobe® Photoshop®

Rick Ferro and Deborah Lynn Ferro

Get the skills you need to make your images look their best, add artistic effects, and boost your wedding photography sales with savvy marketing ideas. $29.95 list, 8½x11, 128p, 100 color images, index, order no. 1753.

Web Site Design for Professional Photographers

Paul Rose and Jean Holland-Rose

Learn to design, maintain, and update your own photography web site. Designed for photographers, this book shows you how to create a site that will attract clients and boost your sales. $29.95 list, 8½x11, 128p, 100 color images, index, order no. 1756.

PROFESSIONAL PHOTOGRAPHER'S GUIDE TO

Success in Print Competition

Patrick Rice

Learn from PPA and WPPI judges how you can improve your print presentations and increase your scores. $29.95 list, 8½x11, 128p, 100 color photos, index, order no. 1754.

Step-by-Step Digital Photography

Jack and Sue Drafahl

Avoiding the complexity and jargon of most manuals, this book will quickly get you started using your digital camera to create memorable photos. $14.95 list, 9x6, 112p, 185 color photos, index, order no. 1763.

Advanced Digital Camera Techniques

Jack and Sue Drafahl

Maximize the quality and creativity of your digital-camera images with the techniques in this book. Packed with problem-solving tips and ideas for unique images. $29.95 list, 8½x11, 128p, 150 color photos, index, order no. 1758.

Creative Techniques for Color Photography

Bobbi Lane

Learn how to render color precisely, whether you are shooting digitally or on film. Also includes creative techniques for cross processing, color infrared, and more. $29.95 list, 8½x11, 128p, 250 color photos, index, order no. 1764.

Take Great Pictures: A Simple Guide

Lou Jacobs Jr.

What makes a great picture? Master the basics of exposure, lighting, and composition to create more satisfying images. Perfect for those new to photography! $14.95 list, 9x6, 112p, 80 color photos, index, order no. 1761.

The Bride's Guide to Wedding Photography

Kathleen Hawkins

Learn how to get the wedding photography of your dreams with tips from the pros. Perfect for brides or wedding photographers who want their clients to look their best. $14.95 list, 9x6, 112p, 115 color photos, index, order no. 1755.

PHOTOGRAPHER'S GUIDE TO
Wedding Album Design and Sales

Bob Coates

Enhance your income and creativity with these techniques from top wedding photographers. $29.95 list, 8½x11, 128p, 150 color photos, index, order no. 1757.

How to Photograph Your Baby's First Year

Laurie White Hayball and David Hayball

Don't miss a moment of your baby's first year. With the easy photo recipes in this book, new moms and dads will be ready to capture the many changes and milestones in their child's development. $14.95 list, 6x9, 112p, 70 color photos, order no. 1765.

PROFESSIONAL TECHNIQUES FOR
Pet and Animal Photography

Debrah H. Muska

Adapt your portrait skills to meet the challenges of pet photography, creating images for both owners and breeders. $29.95 list, 8½x11, 128p, 110 color photos, index, order no. 1759.

The Best of Teen and Senior Portrait Photography

Bill Hurter

Learn how top professionals create stunning images that capture the personality of their teen and senior subjects. $29.95 list, 8½x11, 128p, 150 color photos, index, order no. 1766.

The Best of Portrait Photography

Bill Hurter

View outstanding images from top professionals and learn how they create their masterful images. Includes techniques for classic and contemporary portraits. $29.95 list, 8½x11, 128p, 200 color photos, index, order no. 1760.

PHOTOGRAPHER'S GUIDE TO
The Digital Portrait

START TO FINISH WITH ADOBE® PHOTOSHOP®

Al Audleman

Follow through step-by-step procedures to learn the process of digitally retouching a professional portrait. $29.95 list, 8½x11, 128p, 120 color images, index, order no. 1771.

THE ART AND TECHNIQUES OF
Business Portrait Photography

Andre Amyot

Learn the business and creative skills photographers need to compete successfully in this challenging field. $29.95 list, 8½x11, 128p, 100 color photos, index, order no. 1762.

The Portrait Book

A GUIDE FOR PHOTOGRAPHERS

Steven H. Begleiter

A comprehensive textbook for those getting started in professional portrait photography. Covers every aspect from designing an image to executing the shoot. $29.95 list, 8½x11, 128p, 130 color images, index, order no. 1767.

The Master Guide for Wildlife Photographers

Bill Silliker, Jr.

Discover how photographers can employ the techniques used by hunters to call, track, and approach animal subjects. Includes safety tips for wildlife photo shoots. $29.95 list, 8½x11, 128p, 100 color photos, index, order no. 1768.

Heavenly Bodies

THE PHOTOGRAPHER'S GUIDE TO ASTROPHOTOGRAPHY

Bert P. Krages, Esq.

Learn to capture the beauty of the night sky with a 35mm camera. Tracking and telescope techniques are also covered. $29.95 list, 8½x11, 128p, 100 color photos, index, order no. 1769.

Digital Photography for Children's and Family Portraiture

Kathleen Hawkins

Discover how digital photography can boost your sales, enhance your creativity, and improve your studio's workflow. $29.95 list, 8½x11, 128p, 130 color images, index, order no. 1770.

Professional Strategies and Techniques for Digital Photographers

Bob Coates

Learn how professionals—from portrait artists to commercial specialists—enhance their images with digital techniques. $29.95 list, 8½x11, 128p, 130 color photos, index, order no. 1772.

Lighting Techniques for Low Key Portrait Photography

Norman Phillips

Learn to create the dark tones and dramatic lighting that typify this classic portrait style. $29.95 list, 8½x11, 128p, 100 color photos, index, order no. 1773.

The Best of Wedding Photojournalism

Bill Hurter

Learn how top professionals capture these fleeting moments of laughter, tears, and romance. Features images from over twenty renowned wedding photographers. $29.95 list, 8½x11, 128p, 150 color photos, index, order no. 1774.

The Digital Darkroom Guide with Adobe® Photoshop®

Maurice Hamilton

Bring the skills and control of the photographic darkroom to your desktop with this complete manual. $29.95 list, 8½x11, 128p, 140 color images, index, order no. 1775.

Color Correction and Enhancement with Adobe® Photoshop®

Michelle Perkins

Master precision color correction and artistic color enhancement techniques for scanned and digital photos. $29.95 list, 8½x11, 128p, 300 color images, index, order no. 1776.

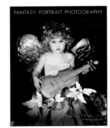

Fantasy Portrait Photography

Kimarie Richardson

Learn how to create stunning portraits with fantasy themes—from fairies and angels, to 1940s glamour shots. Includes portrait ideas for infants through adults. $29.95 list, 8½x11, 128p, 60 color photos index, order no. 1777.